D0925786

Ordinary People

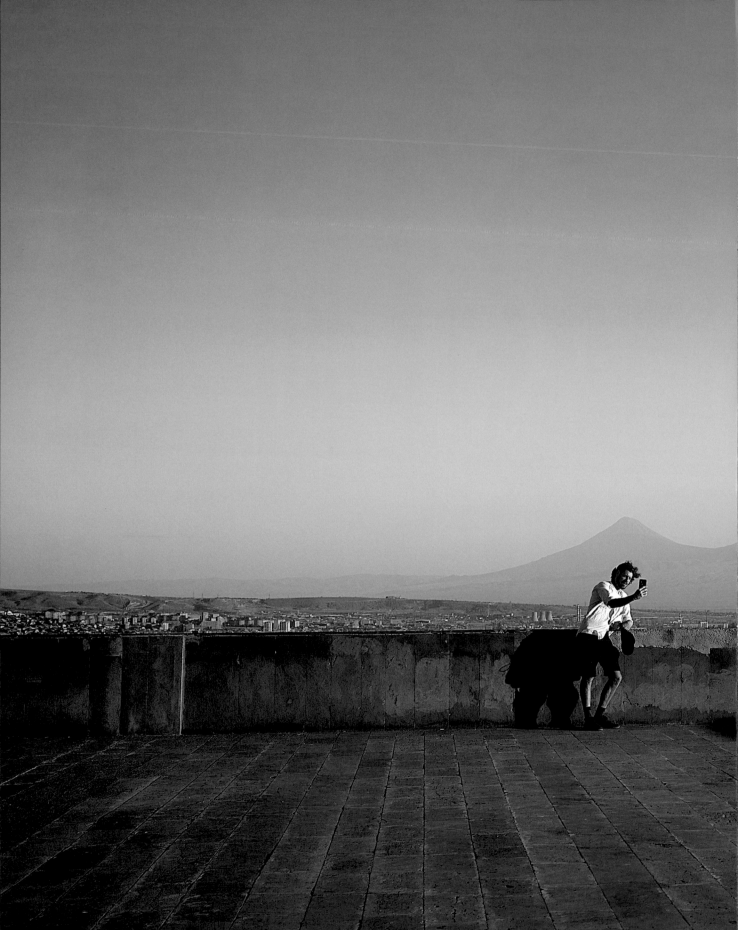

Ordinary People
Portraits from LGBTQ Armenia, Georgia, and Russia

Ksenia Kuleshova

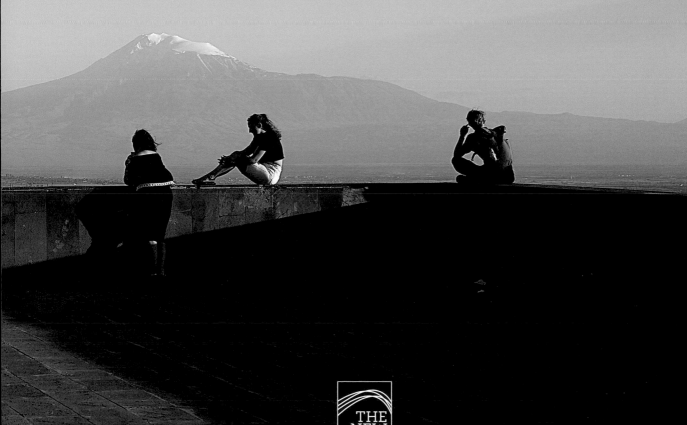

THE
NEW
PRESS

© 2023 by Ksenia Kuleshova
Preface © 2023 by Jon Stryker
Introduction © 2023 by Sasha Kazantseva
All rights reserved.
No part of this book may be reproduced, in any form, without written permission from the publisher.

Requests for permission to reproduce selections from this book should be made through
our website: https://thenewpress.com/contact.

Published in the United States by The New Press, New York, 2023
Distributed by Two Rivers Distribution

ISBN 978-1-62097-793-4 (pb)
ISBN 978-1-62097-827-6 (ebook)
CIP data is available

The New Press publishes books that promote and enrich public discussion and understanding of
the issues vital to our democracy and to a more equitable world. These books are made possible
by the enthusiasm of our readers; the support of a committed group of donors, large and small;
the collaboration of our many partners in the independent media and the not-for-profit sector;
booksellers, who often hand-sell New Press books; librarians; and above all by our authors.

www.thenewpress.com

Book design and composition © 2023 by Emerson, Wajdowicz Studios (EWS)
This book was set in Arek Armenian, FranklinGothic URW, Helvetica, Rama Gothic, and Zapf Dingbats

Printed in the United States of America

10 9 8 7 6 5 4 3 2 1

Preface

This photobook series project was born out of conversations that I had with Jurek Wajdowicz. He is an accomplished art photographer and frequent collaborator of mine, and I am a lover of and collector of photography. I owe a great debt to Jurek and his design partner, Lisa LaRochelle, in bringing this book series to life.

Both Jurek and I have been extremely active in social justice causes: I as an activist and philanthropist and he as a creative collaborator with some of the household names in social change. Together we set out with an ambitious goal to explore and illuminate the most intimate and personal dimensions of self, still too often treated as taboo: sexual orientation and gender identity and expression. These books continue to reveal the amazing multiplicity in these core aspects of our being, played out against a vast array of distinct and varied cultures and customs from around the world.

Photography is a powerful medium for communication that can transform our understanding and awareness of the world we live in. We believe the photographs in this series will forever alter our perceptions of the arbitrary boundaries that we draw between others and ourselves and, at the same time, delight us with the broad spectrum of possibility for how we live our lives and love one another.

We are honored to have Ksenia Kuleshova as a collaborator in *Ordinary People*. She and the other photographers in this ongoing series are more than craftspeople: they are communicators, translators, and facilitators of the kind of exchange that we hope will eventually allow all the world's people to live in greater harmony. ∎

Jon Stryker, philanthropist, architect, and photography devotee, is the founder and board president of the Arcus Foundation, a global foundation promoting respect for diversity among peoples and in nature.

Introduction
SASHA KAZANTSEVA

I remember how I felt hope for the first time in a long while. It was in 2018. I had emailed a key independent Russian publication, pitching them an article on lesbian sex education—a topic that had never been covered in the Russian media. The "anti-LGBTQ propaganda" law, which threatened any person or media that chose to talk about LGBTQ issues, had been in force for five years. I was entirely ready for rejection but, to my surprise, the editor responded: "Great idea, let's do this. And do you have some more topics like this?"

It was a reply I could not have imagined receiving after 2013, when the anti-LGBTQ propaganda law was passed. The law, which forbade "LGBTQ propaganda" without defining what "propaganda" entailed, was intentionally vague to allow the authorities to prosecute any individual in a particular group. We were familiar with the previous similar "extremism law," and so we knew how it would work: propaganda could be anything they wanted it to be, even the smallest mention of queer people. The main goal was to create fear: among all LGBTQ people in the country, among any independent media that might cover queer issues, among any straight people who might express their support for the LGBTQ community. These laws created a new public enemy. Attitudes about LGBTQ people had not been friendly even before that, but I remember the deafening silence that followed the passing of that law—the moment the media suddenly stopped talking about us at all. I remember how many LGBTQ people around me felt fear, how those who had the opportunity to do so fled the country.

So what changed in 2018? Why was everything unfolding so quickly? What gave so many of us hope? Why were journalists, including me, able to start covering LGBTQ culture in popular media outlets unopposed? Why did so many queer people start launching blogs? Why were people holding queer events? Why were independent filmmakers making movies about the community? Why were some celebrities starting to express their support?

It seemed like we had reached some kind of critical mass—a critical mass of people who were tired of being afraid. The winds of queer freedom were beginning to blow through our lives. Later, in hindsight, we realized that the first years of the "propaganda" law also coincided with the rise of social media. We could see openly queer people throughout the world, how they lived and what they created. It left a deep impression. Also, a new generation of queer activists were ready to push boundaries. Yes, police descended on LGBTQ lectures and performances, it was hardly possible to publish a book on LGBTQ themes in Russia, my friends were attacked on the street, and, like many activists, I was forced to have a safety plan for emergencies like governmental prosecution—but we looked upon all of these as routine. When you live under a certain level of threat, you can become accustomed to it. Still, many of us believed that change for the better was possible.

In 2018 I started my LGBTQ sex education blog, which became popular rather quickly. By the end of the year, some fellow queer journalists and I launched *O-zine,* an independent publication about Russian queer culture, which became well known in the community even outside the country. I gave talks on LGBTQ issues for a broad range of people, including journalists, writers, and doctors. But I remember the contrast: when I gave those lectures in smaller cities, the organizers would remove "LGBTQ" from announcements and used euphemisms to avoid any potential violence or problems with the authorities.

The year 2018 was also when Ksenia got the idea for the book you have in your hands. Ksenia explains she named her project *Ordinary People* because not only are LGBTQ people demonized by the government and state media, but they are also frequently exoticized by straight people. Many "ordinary Russians" don't even believe non-heterosexual or transgender people exist in their country, or claim they know nobody "like that." Ksenia says, "I wanted to convey how these people live their daily lives. How they drink tea in their kitchens, how they work, how they spend time with their friends, how they love. Simple things that are shared by all people throughout the world."

Ordinary People came together over an extraordinary few years for the LGBTQ community of Russia. Ksenia embarked on *Ordinary People* in 2018 and continued taking photographs for this project for five years. She took the final photographs in the series in 2022, a year marked by Russia's full-scale invasion of Ukraine, which has led to genocide and unimaginable tragedy. Within Russia, the totalitarian government clamped down on any form of dissent. People left the country in historic numbers. LGBTQ people who have always opposed the government were among those fleeing. By the end of the year, a new, even harsher version of the anti-LGBTQ propaganda law was introduced. And as I write this, the government is adopting a law forbidding trans people from transitioning. From today's perspective, the world in which Ksenia started working on *Ordinary People* seems like an elusive dream.

What has happened in these five years? How were things changing? Who are the people in the photos, and what made them take part despite the risks involved?

When an LGBTQ person from Russia sees published photos of other queer Russians, one of the first thoughts they often have is "There must be a reason why these people don't mind being photographed." Then they can't help but start analyzing the factors that allowed them to be so openly queer. Do they have those rare jobs where they will not be fired for revealing their queerness? Are they some of the lucky few whose parents accept them? Do they live in a city large enough not to be hunted down and beaten? Are they those activists brave enough to face repression for their openness? Are they those who just refuse to hide in protest?

And you will notice, as you look through these pages, that you won't find, for good reason, people from small villages—where patriarchal ideas often have a greater hold and where people have limited access to information or are just too exhausted by daily survival in the most conservative regions in Russia, such as Chechnya, a territory that was occupied by Russia in the 1990s, and since then became famous for its brutal torture of LGBTQ people.

As I look through these photographs, I am particularly struck by one portrait of an older woman, Elena, which speaks volumes. I always feel a particular excitement when I look at photographs of older queer people from other countries because in Russia we hardly ever see them. The older generations of LGBTQ people, who lived in the USSR under permanent risk of being arrested, are used to the idea that being invisible means being safe. They prefer a very closed lifestyle. We have very little information about them, and this lack of connection between generations definitely affects the confidence of young queer people. Having Elena agree to have her portrait taken means much more than one could imagine.

As a Russian, I understand why the only photo of a child in the book is of a family living abroad, having fled Russia for Georgia. The last thing a queer family in Russia would do is show their children publicly. Families with children have always been the most vulnerable under the Russian homophobic and transphobic laws.

The last photos for *Ordinary People* were taken in Georgia and Armenia—two primary locations for queer and political refugees from Russia because they are relatively safe and require no visa. "We got so much support from the local queer community," says Tatiana, a bisexual woman who moved from Russia to Armenia. "As far as I can see, local LGBTQ organizations are not being persecuted by the authorities, unlike in Russia."

In these pages we also see Georgian and Armenian LGBTQ people and their narratives appear in the frame. According to Georgians and Armenians, neither country is LGBTQ friendly. Georgia is the only country of the two that officially has LGBTQ pride marches, but each year they are attacked by far-right protesters. "Despite this, they get longer each year," says Sofi, a Georgian trans woman. "Georgia is a very patriarchal and religious country, and many young people leave it for a better life. But I believe in a better future for us; we should not give up." Sofi's compatriot Shota, a gay man, sees his future as an activist working toward a more inclusive and accepting society: "By standing up for the rights of LGBTQ individuals and amplifying their voices, I hope to contribute to a future where everyone can live authentically and without fear of prejudice or discrimination."

Some Georgians and Armenians want to leave. Emma, an Armenian lesbian, doesn't see a future for herself there: "I cannot legitimize my partnership, and my family is really conservative; they will never accept my choice or support me. People here fear being outed. I still feel this fear deep inside, but what is life without some risk?"

Kelly, an openly gay, gender-fluid Armenian, generally agrees, but intends to fight: "For openly gay people like me, it's almost impossible to find a job in Armenia. But I've come to the realization that I have a duty, a mission in Armenia—to fight for legal and social change."

Both Georgia and Armenia have suffered at the hands of Russia: for instance, in 2008, Russia invaded Georgia as it is invading Ukraine now, and some Georgian territory remains occupied. This affects how the wave of Russian refugees is perceived here and makes many Russians reflect upon their country's history more deeply.

Many of us have never learned the full extent of Russian aggression and the atrocities it has committed. For many, it took the invasion of Ukraine for the realization to sink in. They learned even more when they emigrated to the nearest countries and spoke with the people living there. When I ask Russians to name the most intense emotions they have recently felt, they say fear, guilt, shame, horror, and anger. They describe their attempts to take the responsibility for those horrors and to do what they can, but at the same time not to drown in a guilt that can become destructive. Many found a balance in volunteering, which has become especially widespread in the LGBTQ community.

The differences in the conditions for locals and those arriving from Russia extend to other areas of daily life: "The first thing I remember about Russian people coming to Armenia is that it resulted in my friends becoming homeless," recalls Kelly. "Because Russian people have more money, rentals have almost doubled in price since their arrival. This

mostly affected the poor trans community. Most trans women are kicked out at an early age and have to become adults sooner than they're supposed to."

Shota mentions a similar tension: "The complex history and strained relations between our countries and the actions of the Russian government in the past, along with perceived lack of trustworthiness, contributes to insecurity and mistrust I and people around me feel toward Russians. We have questions about what Russians will do if their government decides to attack Georgia again."

Sofi says she sees some better sides to the situation: "I'm against the ones who support the war, but those who had to flee the country because they cannot live there—that's a different thing. But they should not forget they are guests here, should respect our rules, and be thankful for the country that accepts them. My Russian friends are learning Georgian and understand why they sometimes become the subject of impulsive aggression from the locals, because they see the situation is complicated."

There's an idea that LGBTQ people from different countries have more opportunities to establish contact with each other. "However, the Russian queer community made Armenia more diverse," says Kelly. "I have amazing Russian queer friends who have started learning Armenian, and they make plenty of positive changes inside the community. Their contribution is immense! Although I find the Russian influence very destructive for my country, I still do understand that a lot of Russian people do not share the ideologies of their government. They are survivors of the regime."

"Probably, the Russian government's next step will be to criminalize homosexuality. They see us as 'enemies of the state,'" says Maria, a lesbian from Russia who has lived in Georgia for many years. But most LGBTQ people in Russia will not be able to go abroad because they are too poor. Most Russians don't even have international passports that would allow them to travel abroad. This applies to trans people, who have always been the most vulnerable part of the community. Trans activists who stay in Russia say that with the new law prohibiting transition, the trans community will have to go underground, become even more closed, and lose any opportunity to integrate their lives into Russian society.

Sofiya, a lesbian living in Irkutsk, a Siberian city in Russia, wants to one day move to a country where same-sex marriages "are not illegal" and where she will be able to raise children in a safe environment. Her partner, Valeriya, finds it difficult to find anything good to say about Russia: "There is going to be nothing positive here; the level of aggression constantly increases. They say LGBTQ people are something Russia should eliminate as if they are a disease. The part of the community that won't be able to emigrate will go into hiding. But there will also be activists who will fight for their rights until they are jailed. There are still many brave people."

One of those brave activists is Ilfat. "I believe in a bright future because, despite the terrible laws and all the darkness that the Russian government created, I and other people from the community keep resisting," he says. "We keep speaking out loudly against the war and violence as much as we can! Yes, we get our homes searched by the police, we get arrested, and our stuff gets confiscated, and there's nothing convenient about it; it's scary. But we keep doing what we believe in. We keep loving and supporting each other. And as we do so, there is a hope that love will win. It's inevitable because love is stronger than hate." ∎

From the Photographer
KSENIA KULESHOVA

This book is dedicated to all the heroes who took part in *Ordinary People*. I am honored and grateful that you have shared your story with me and thank you for every meeting, every moment, every tear and laugh we shared together. I get emotional when I look back and remember each one of you, my dear friends.

Although the idea of the project was to catch the most ordinary moments that everyone has in life despite their orientation, each one of you is special. It is so easy to lose hope and faith in these difficult times, but your courage, bravery, and desire to live openly and freely is what proves that good always triumphs over evil!

With love, Ksenia

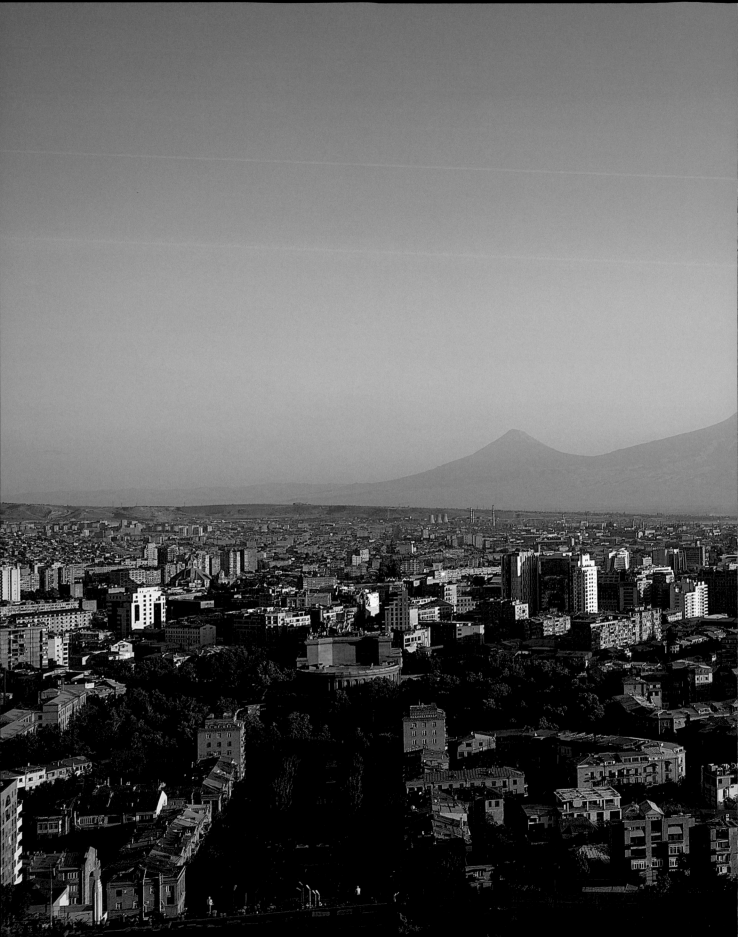

Armenia

Հայաստանի
Հանրապետություն

**The Republic of Armenia is
a landlocked country in the
Armenian highlands of Western
Asia. Boasting a history longer
than most European countries,
it is part of the Caucasus region
and is bordered by Turkey to
the west, Georgia to the north,
Azerbaijan to the east, and
Iran and the Azerbaijani exclave
of Nakhchivan to the south.
Its capital is Yerevan.**

Yerevan, Armenia. The vista from the viewing platform of Cascade Complex
with Mount Ararat (currently located in Turkey) visible in the distance.

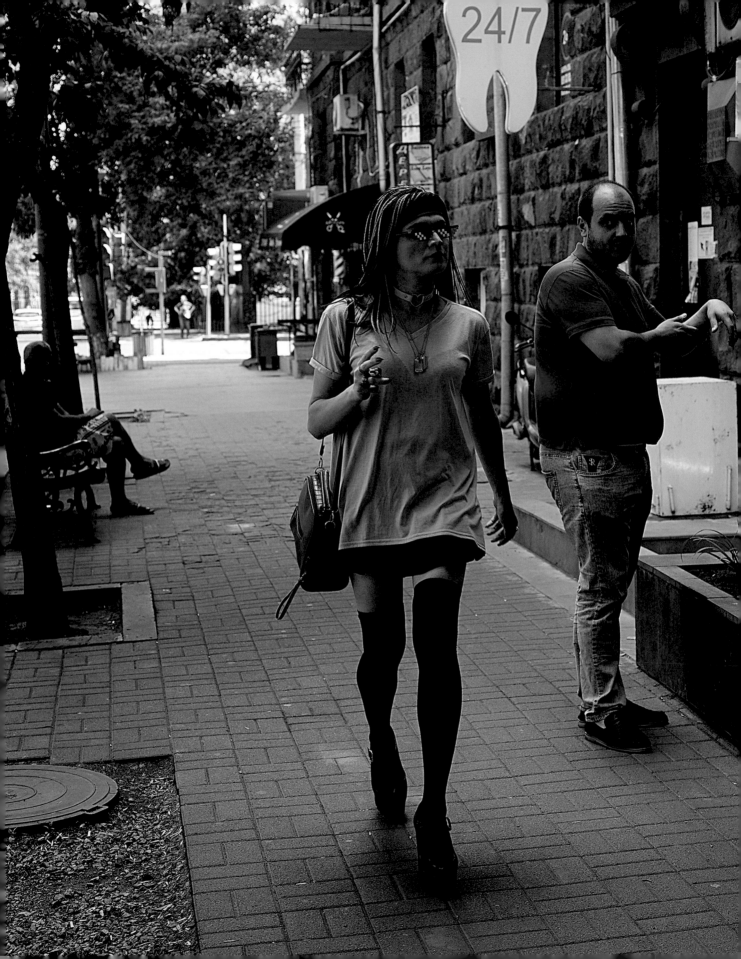

Alice
Ալիս

Yerevan, July 2022.
Alice, a trans woman, in her hometown Yerevan. Although she came out to her parents when she was twelve, it wasn't until her father passed away in her late teens that she finally let go of her fear of public judgment. Her journey has not been an easy one. At one point, she was attacked on the street. Today, she finds joy and creativity as a 3D jewelry modeler.

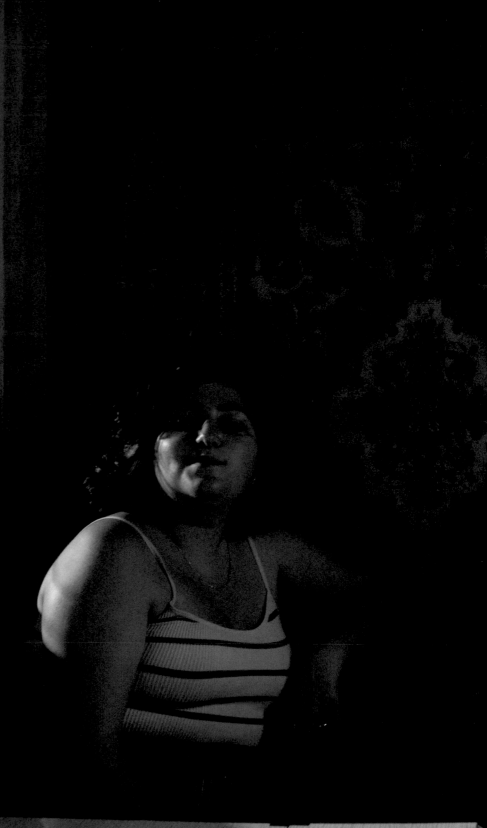

Emma
Էմմա

Elena
Елена

Tatiana
Татьяна

Yerevan, July 2022.
Emma (left) is from Armenia and studying to work in advertising. She has not come out to her parents, but she otherwise openly identifies as lesbian. Elena (center) is also openly lesbian. She left Russia in the wake of the invasion of Ukraine and now lives in Gyumri, Armenia, where she leads charities dedicated to supporting children with special educational needs. Tatiana works as a quality assurance engineer. Openly bisexual, she is from Rostov-on-Don, Russia, and sought refuge in Yerevan just one week after Russia's invasion of Ukraine. Elena and Tatiana started dating after their paths crossed in Armenia.

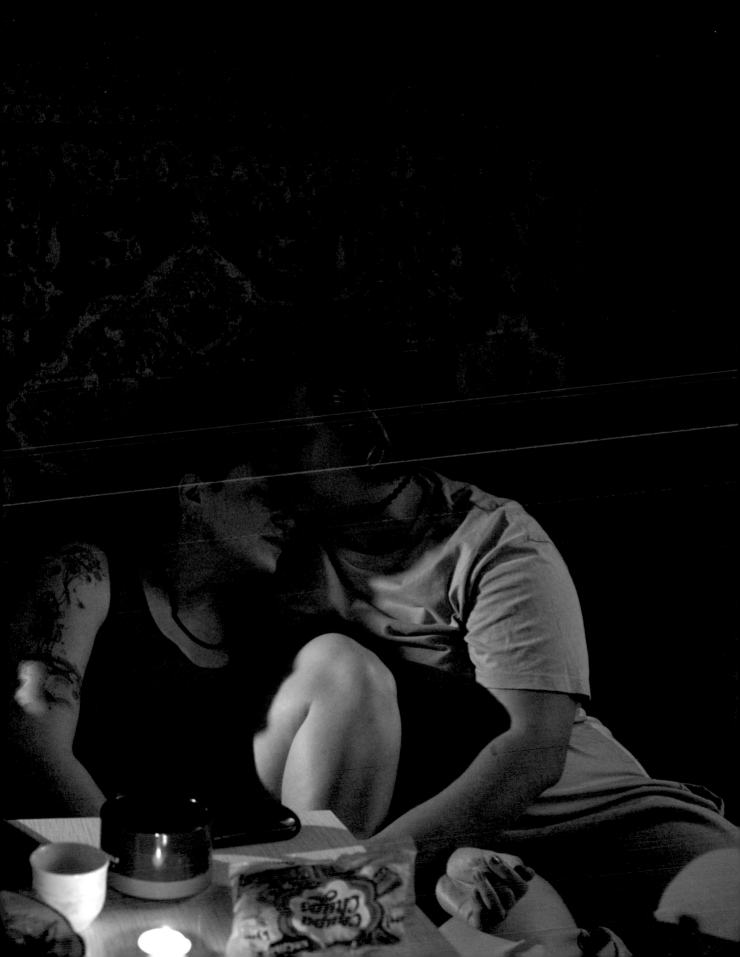

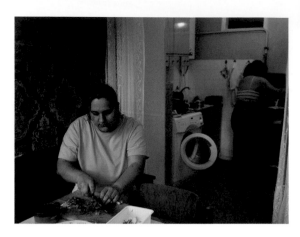

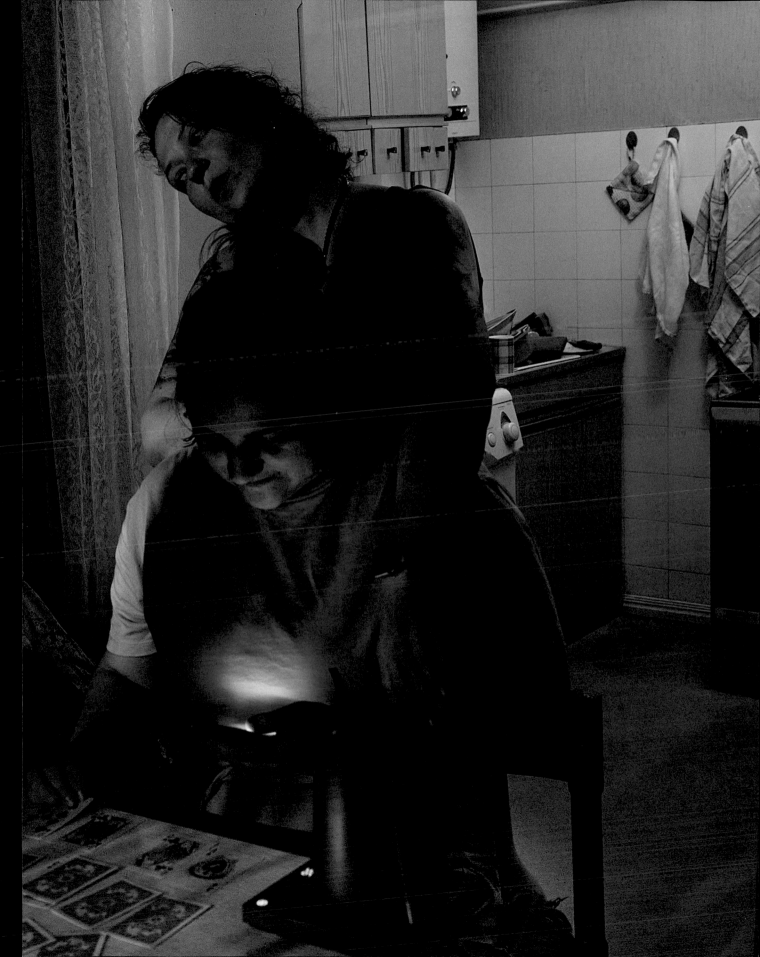

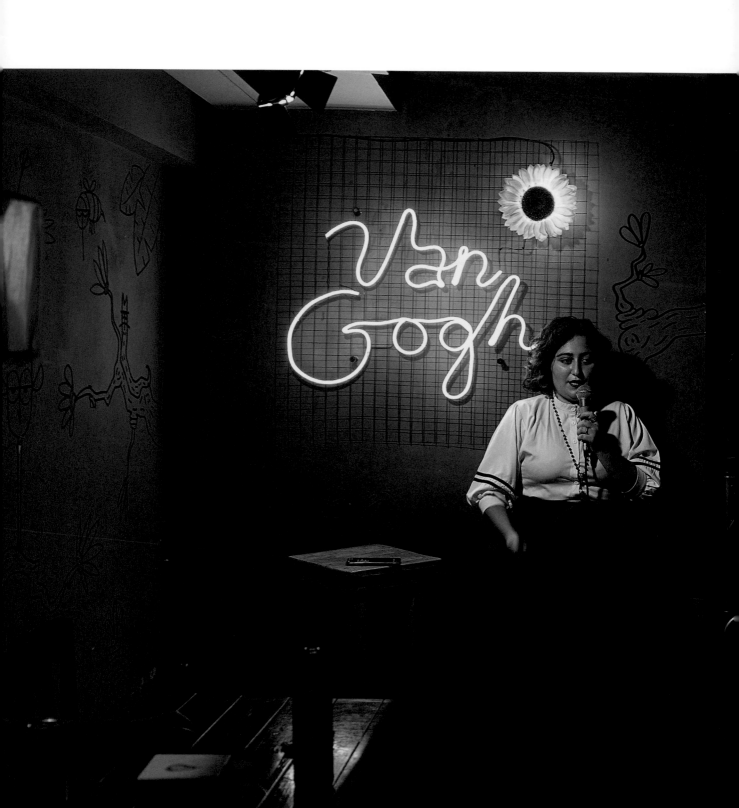

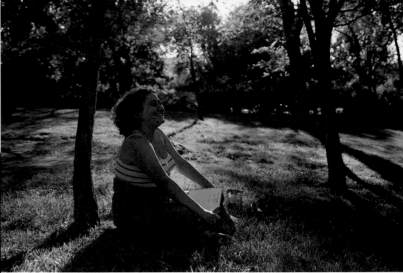

Yerevan, July 2022.
Emma does stand-up at a local bar.

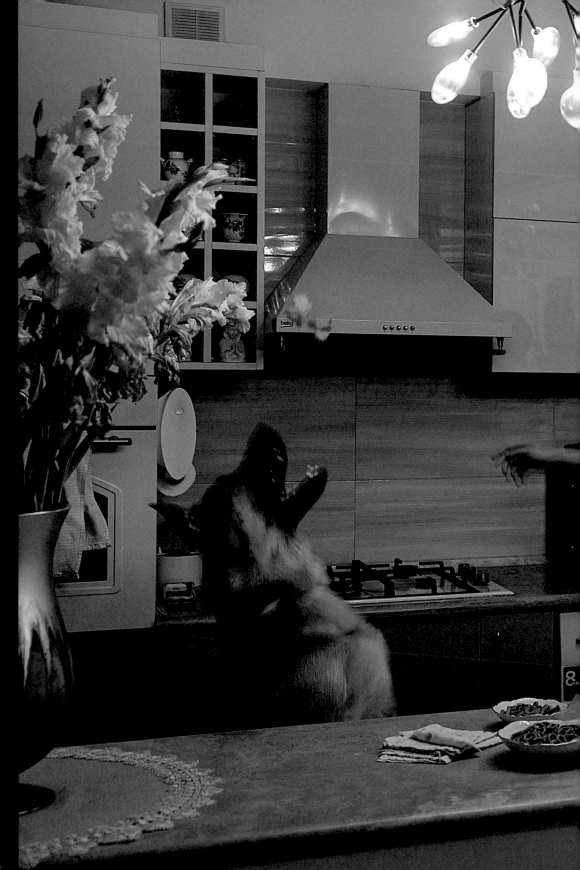

Natalie
Նատալի

Kelly
Քելլի

Yerevan, July 2022.
Natalie and Kelly in Natalie's kitchen. Natalie came out to her parents as a lesbian at age fifteen, although she remains cautious about openly discussing her sexuality due to her father's position in government. Kelly, Natalie's best friend, identifies as gay and gender-fluid. Fluent in English and Spanish, Kelly is a passionate LGBTQ activist

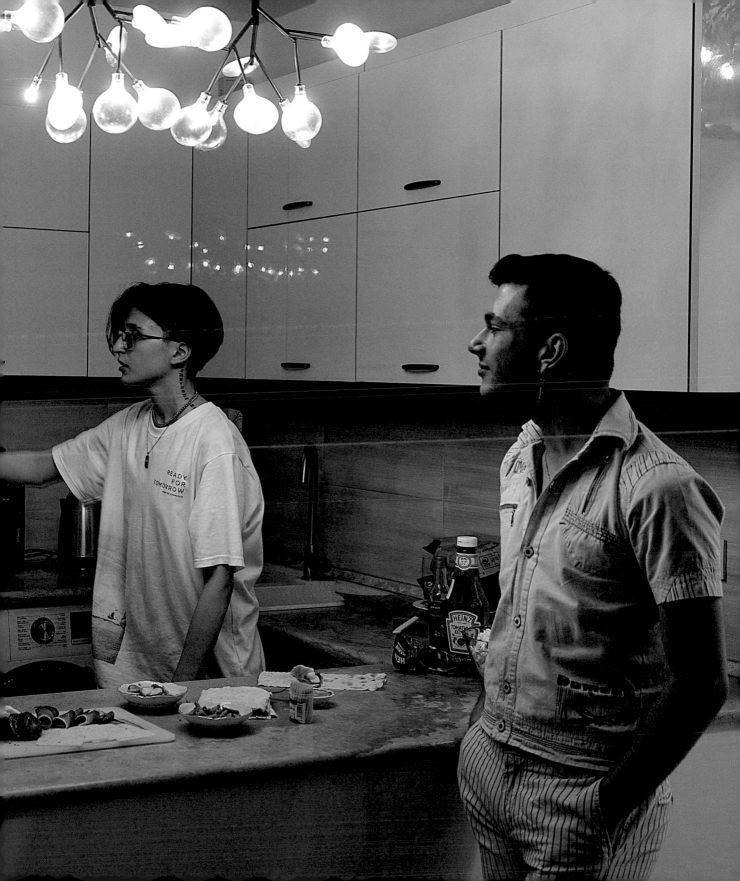

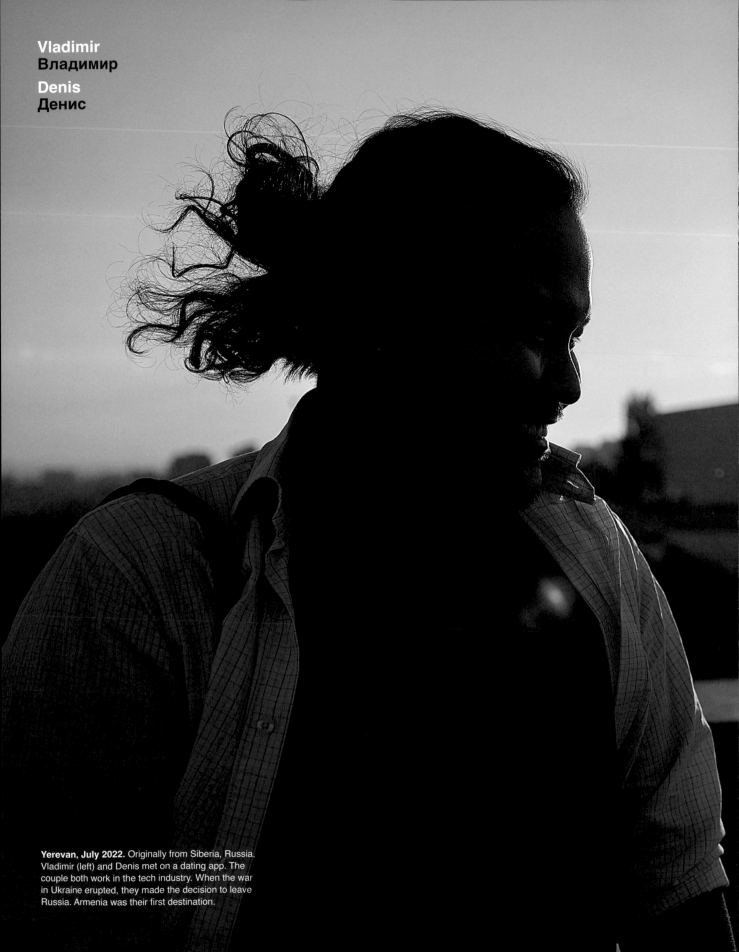

Vladimir
Владимир

Denis
Денис

Yerevan, July 2022. Originally from Siberia, Russia, Vladimir (left) and Denis met on a dating app. The couple both work in the tech industry. When the war in Ukraine erupted, they made the decision to leave Russia. Armenia was their first destination.

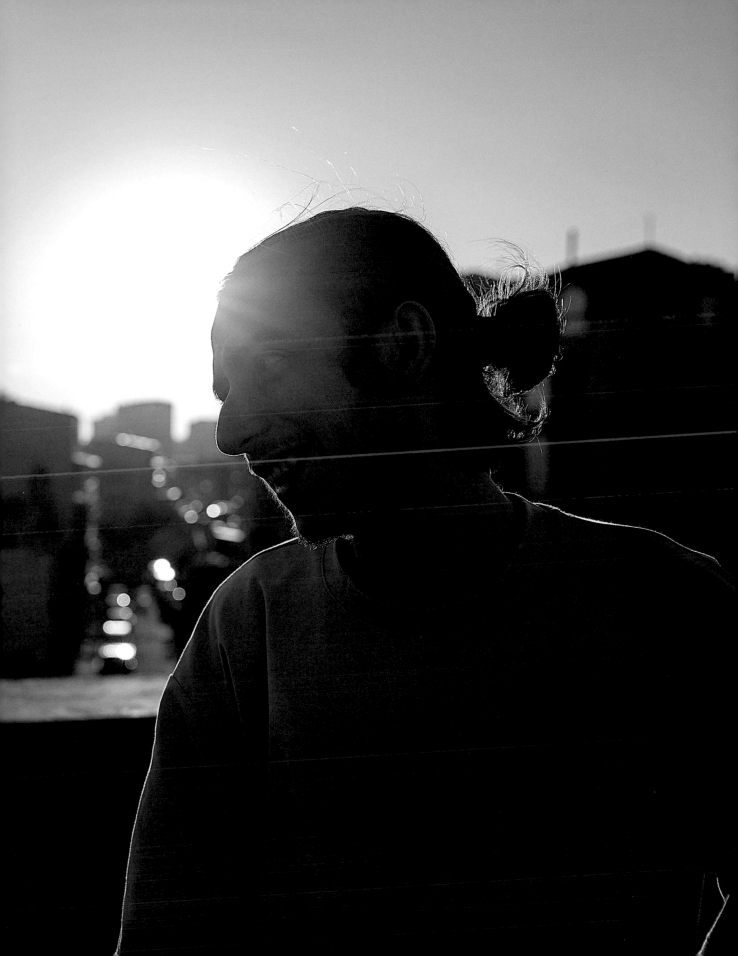

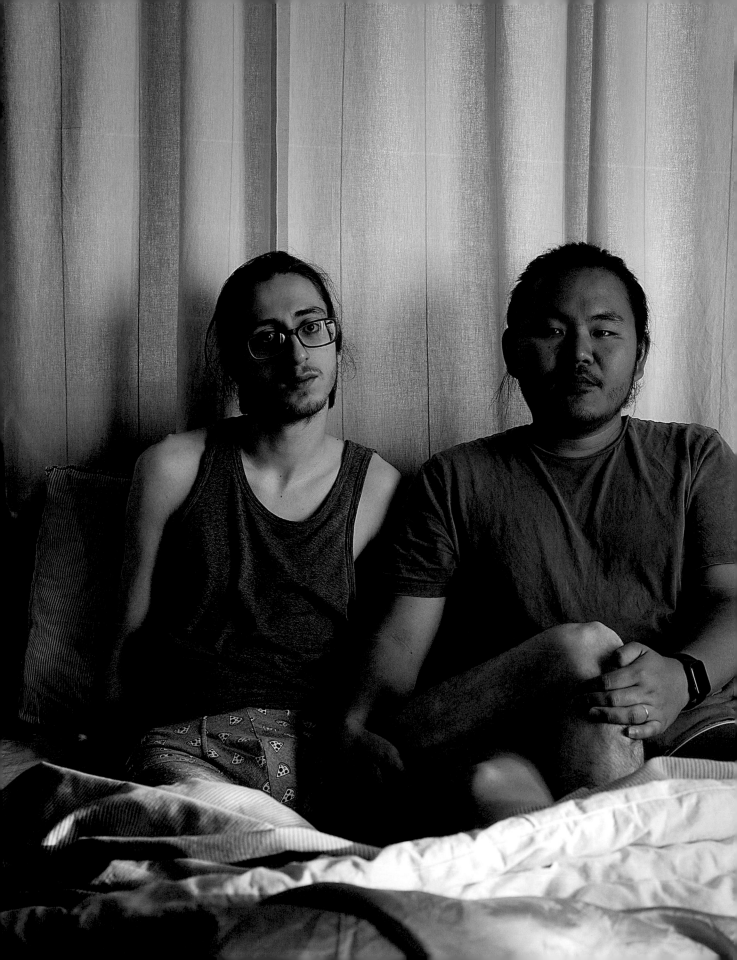

Vladimir fashions a ring for Denis out of a flower at Lake Sevan.

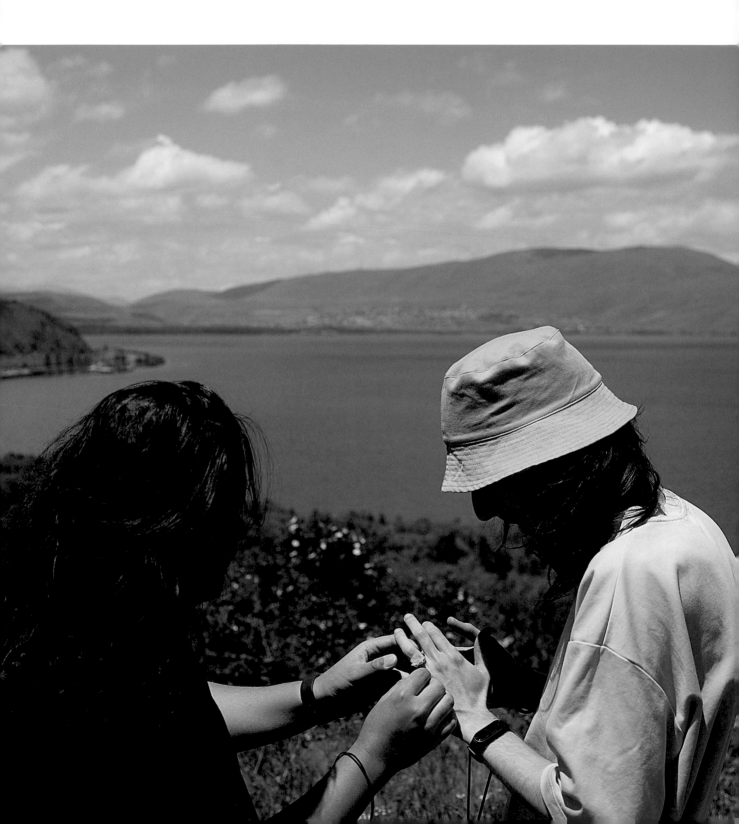

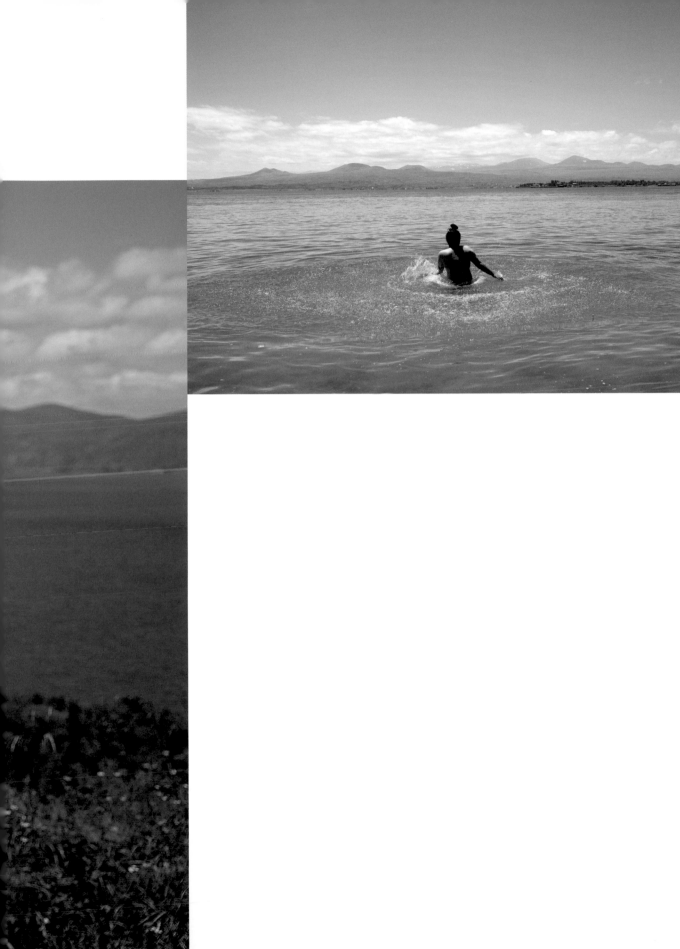

The Tbilisi Sea, Georgia.

Georgia
საქართველო

Georgia lies at the intersection of Eastern Europe and Western Asia. It is part of the Caucasus region, bounded by the Black Sea to the west, Armenia to the south, Russia to the north, Turkey to the southwest, and Azerbaijan to the southeast. The country covers an area of 26,900 square miles and has a population of 3.7 million people.

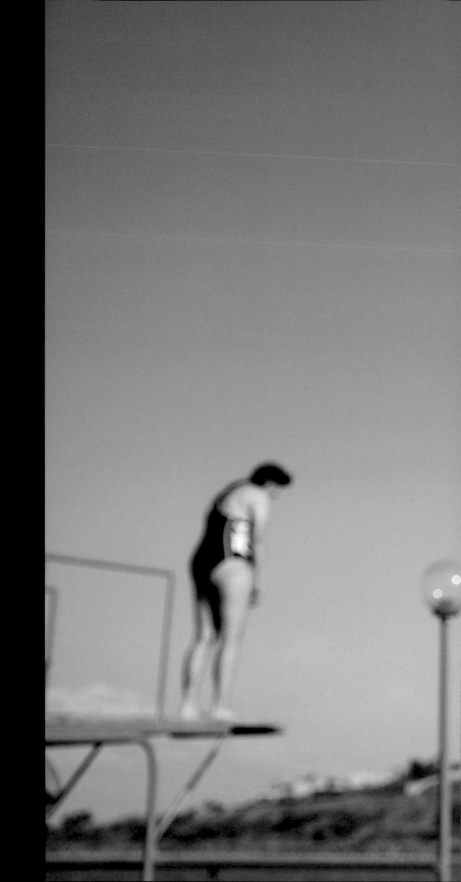

Maria
Мария

Tbilisi, July 2022.
Maria on the coast of the Tbilisi
Sea. She is a journalist, LGBTQ
activist, and the founder of the
blog *Lesbian Lobby* ("Лесбийское
лобби" in Russian). She co-
hosts the podcast *Wide Open*
("Нараспашку"), which delves
into LGBTQ culture. Maria
is excited about an upcoming
project she is doing with a friend—
a queer zine called *On Yourself*
("На себя"). She moved to
Georgia in 2019.

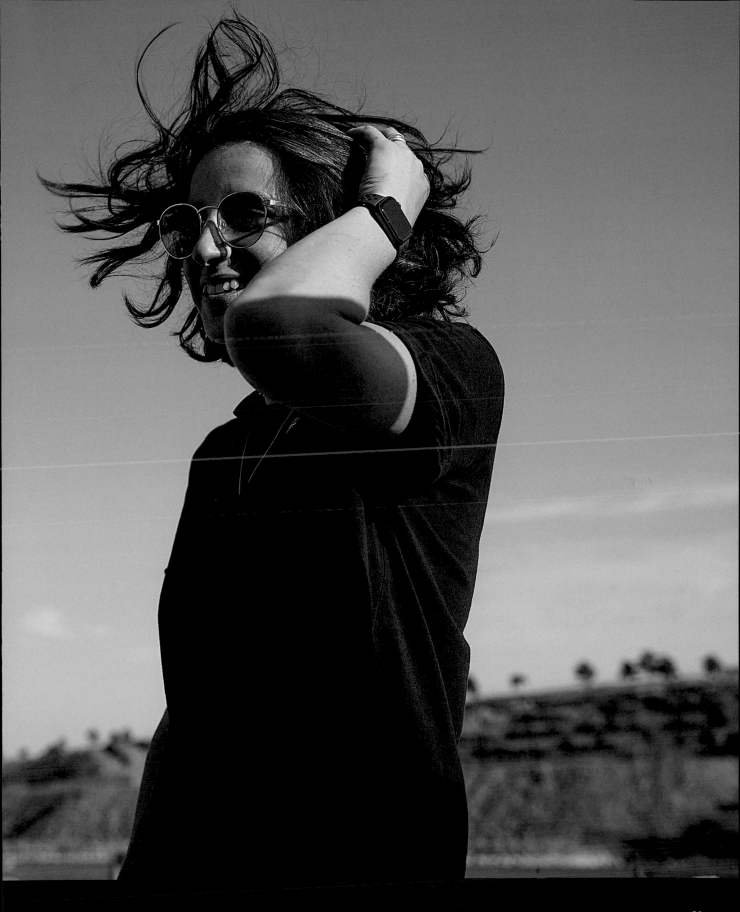

Ivan
Иван

Tbilisi, July 2022.
Originally from Tyumen, Russia,
Ivan proudly identifies as queer.

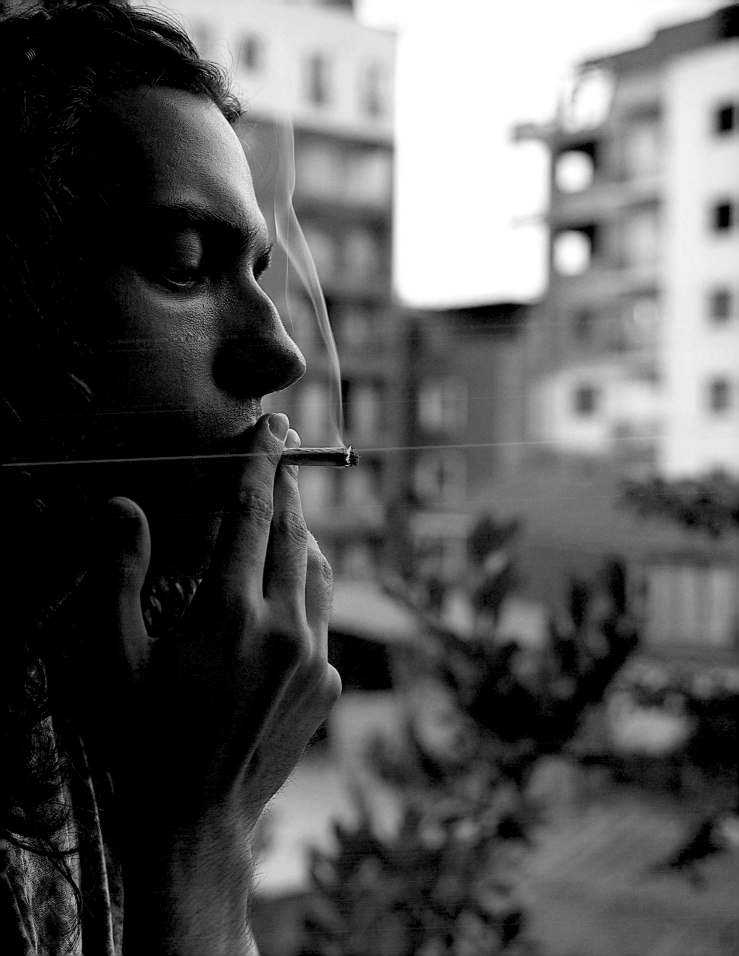

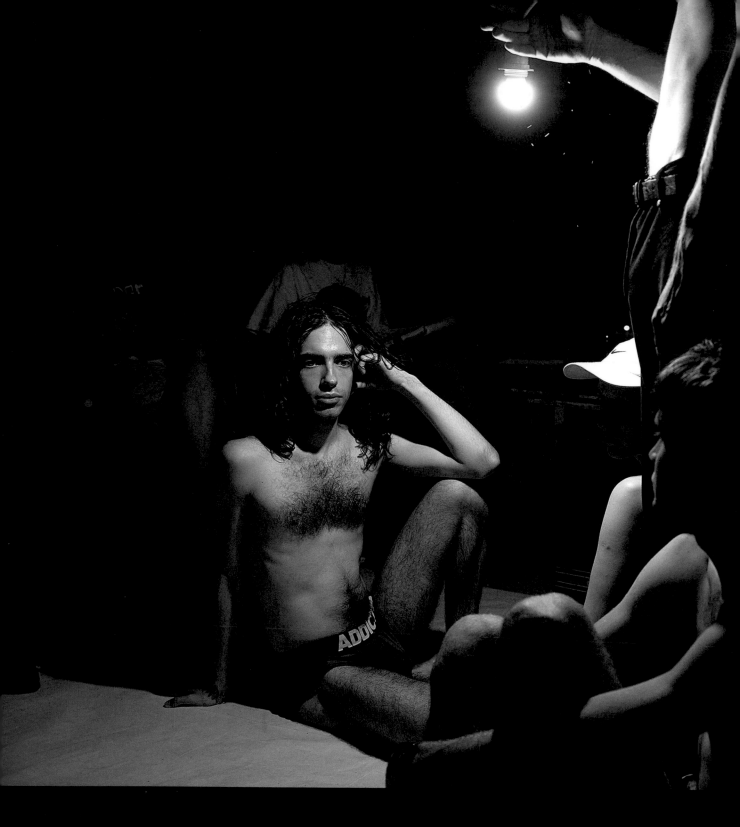

Tbilisi, August 2022.
Ivan strikes a pose at a drawing class.

Maria
Мария

Elena
Елена

Batumi, August 2022.
Maria (left) embraces Elena.
Openly pansexual, Maria is
a member of a polyamorous
family of three. Her journey from
Russia to Georgia began when
she followed one of her girl-
friends. She ultimately decided
to stay and make it her home.

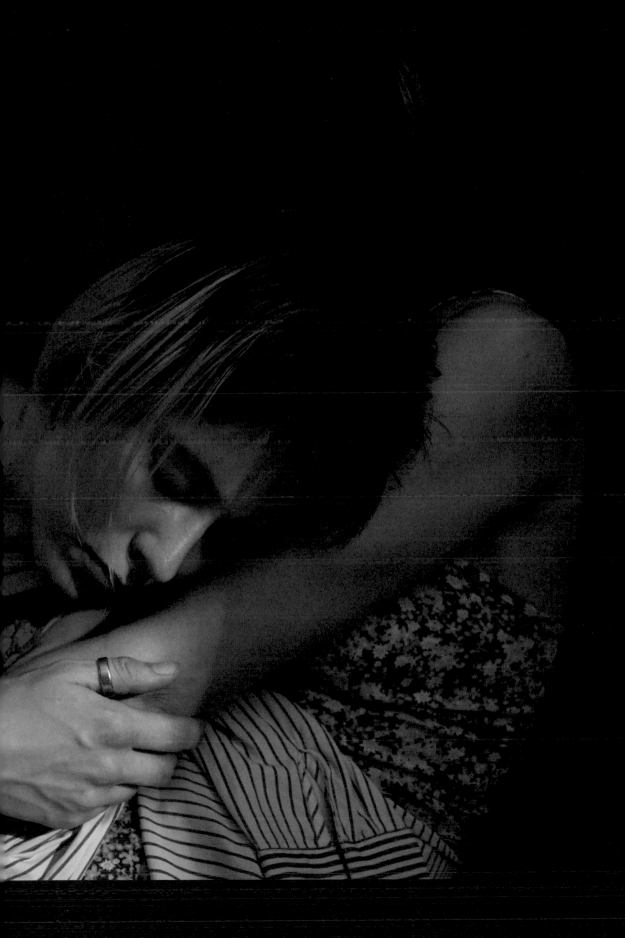

Alisa
Алиса

legions
легионы

ani kto
эни кто

Arseniy
Арсений

Seryozhi Che
Серёжы Че

Tbilisi, August 2022.
From left to right: Alisa, legions, ani kto, Arseniy, and Seryozhi Che. Seryozhi Che are a nonbinary artist, curator, stage director, and video maker. ani kto are a performance artist, illustrator, and genderqueer model from Siberia, Russia. They also identify as nonbinary although their mother continues to refer to them with "she/her" pronouns and once said that homosexuality is worse than war. Seryozhi Che and ani kto have been married for three years and they are Arseniy's parents. They relocated to Georgia after Russia invaded Ukraine. ani kto are also in a relationship with legions, a nonbinary lifeform also known as leo. legions are an openly trans artist, specializing in queer rap and multidisciplinary contemporary composition. Born in Perm, Russia, they had been married to a heterosexual woman for nearly five years. legions also moved to Georgia following the war in Ukraine. Alisa is a partner of Seryozhi Che.

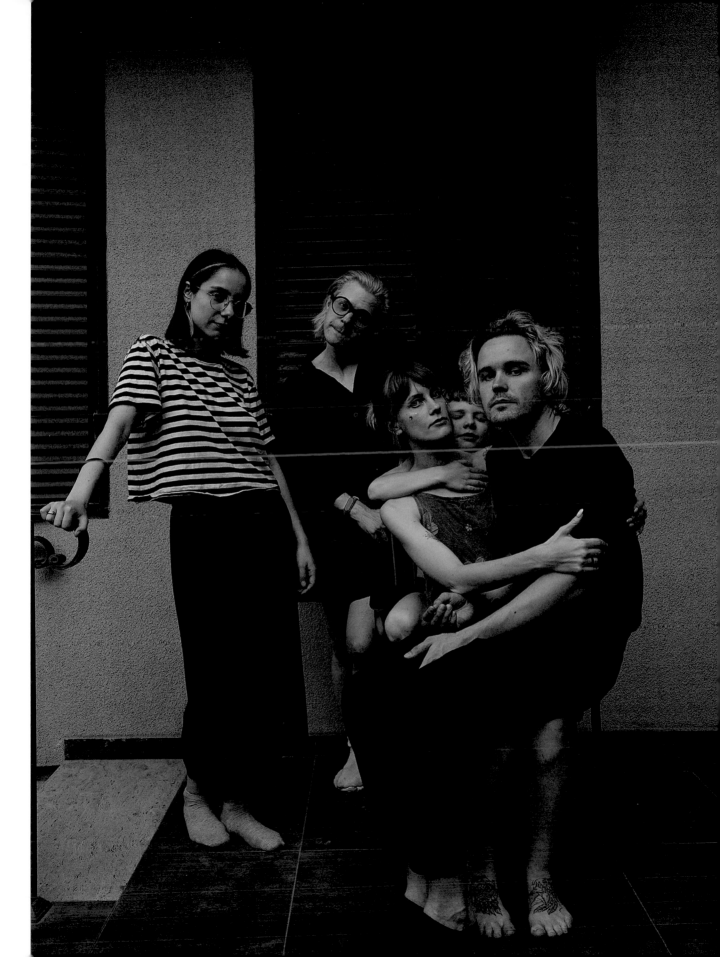

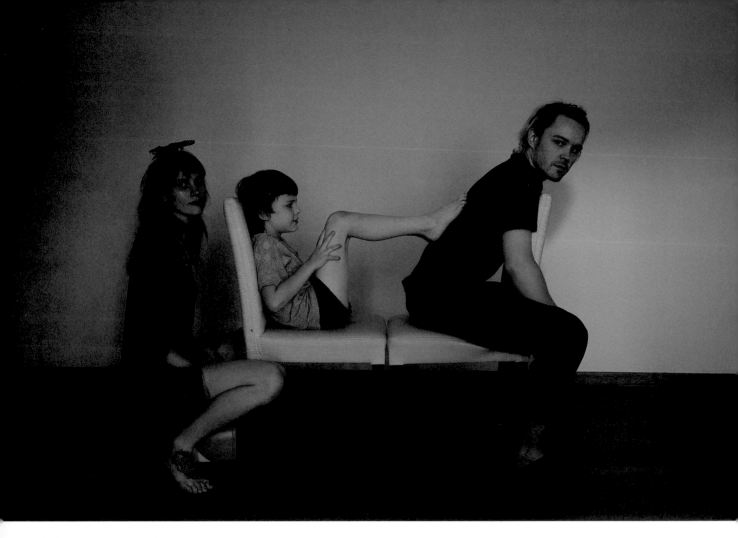

Tbilisi, August 2022. A portrait of a queer family staged by Arseniy.

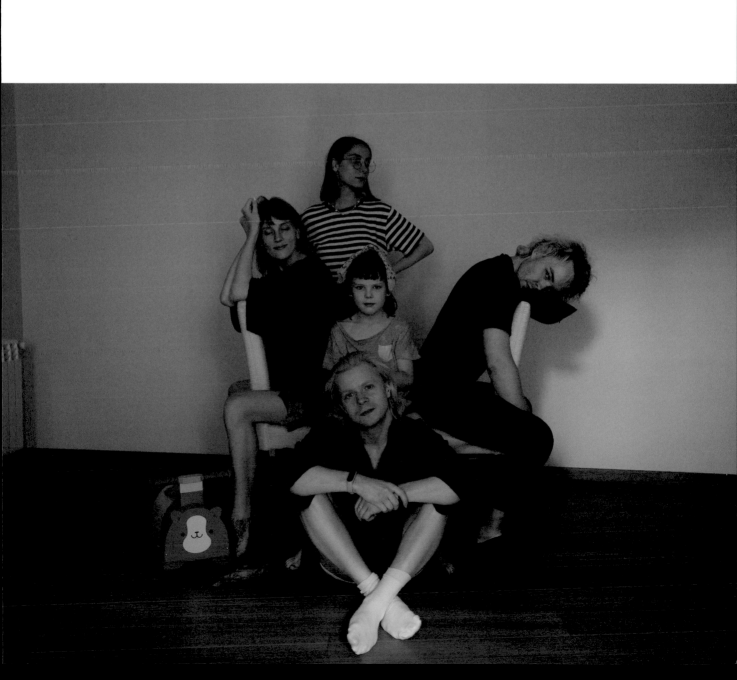

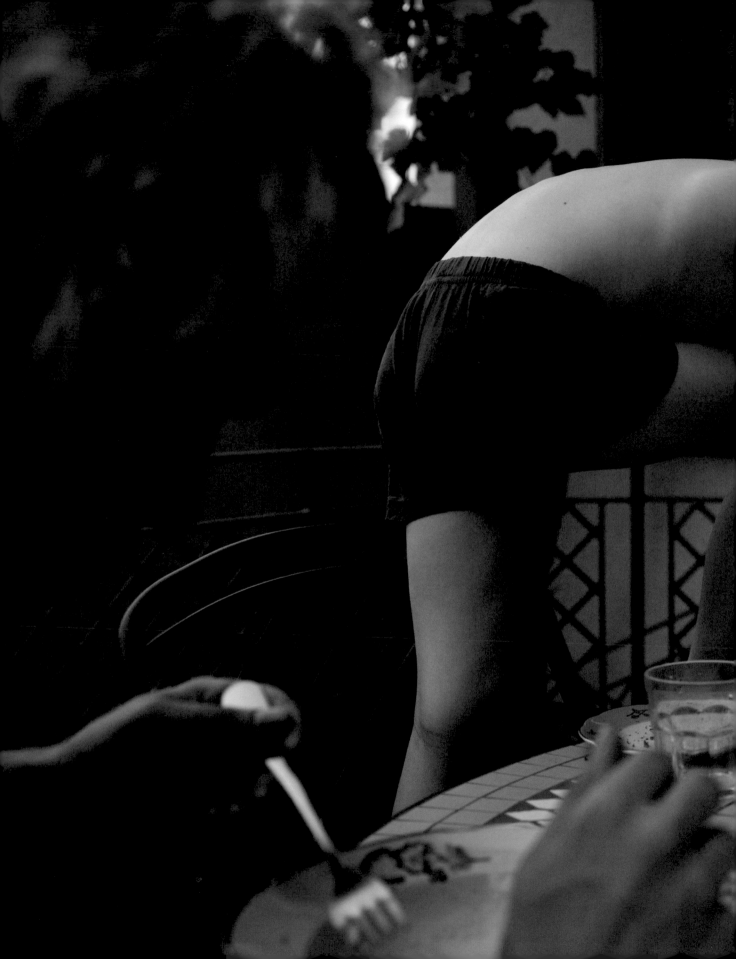

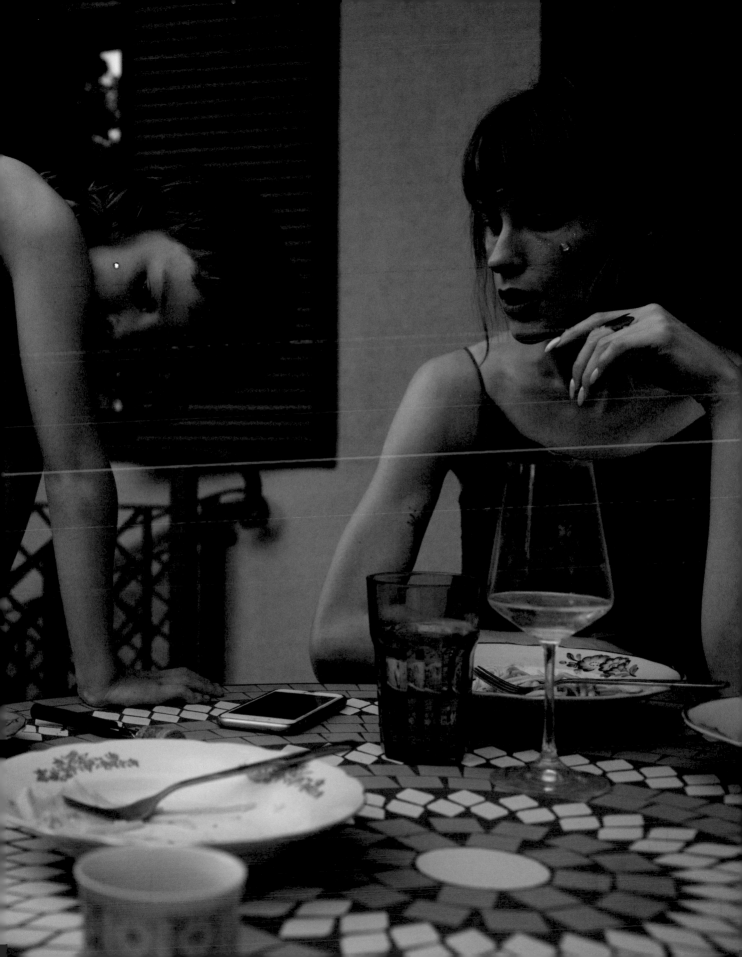

Stas
Стас

Andrei
Андрей

Tbilisi, August 2022.
Stas (left) and Andrei are a gay
couple from Siberia. Stas is a
psychotherapist, while Andrei is
a photo editor. They met online
on LiveJournal and then in
person in Odessa. They have
been together for fifteen years,
although they have broken up
a few times along the way.

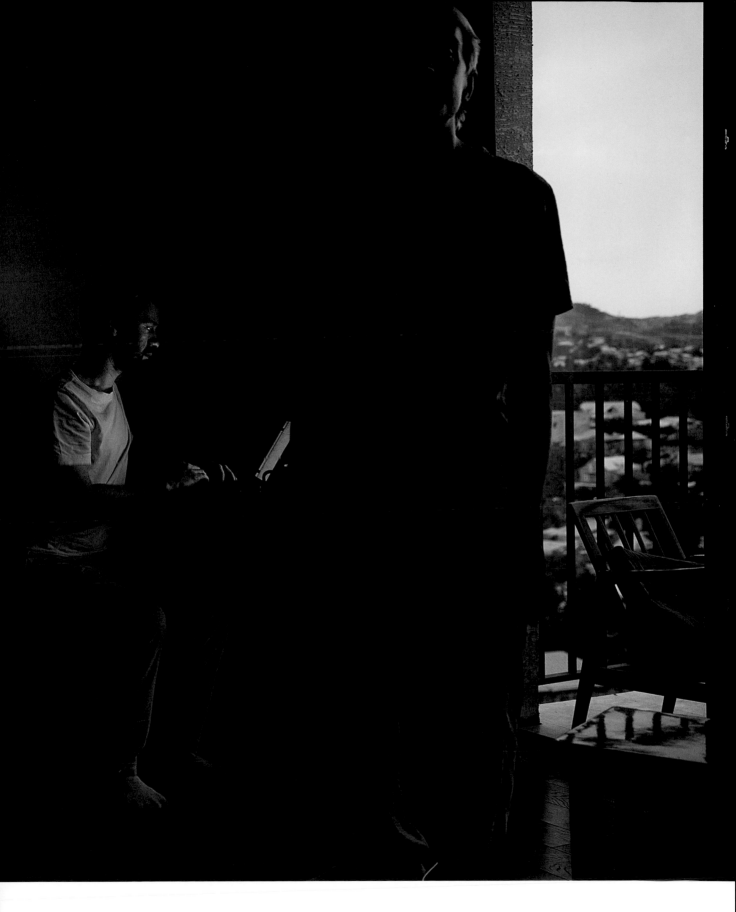

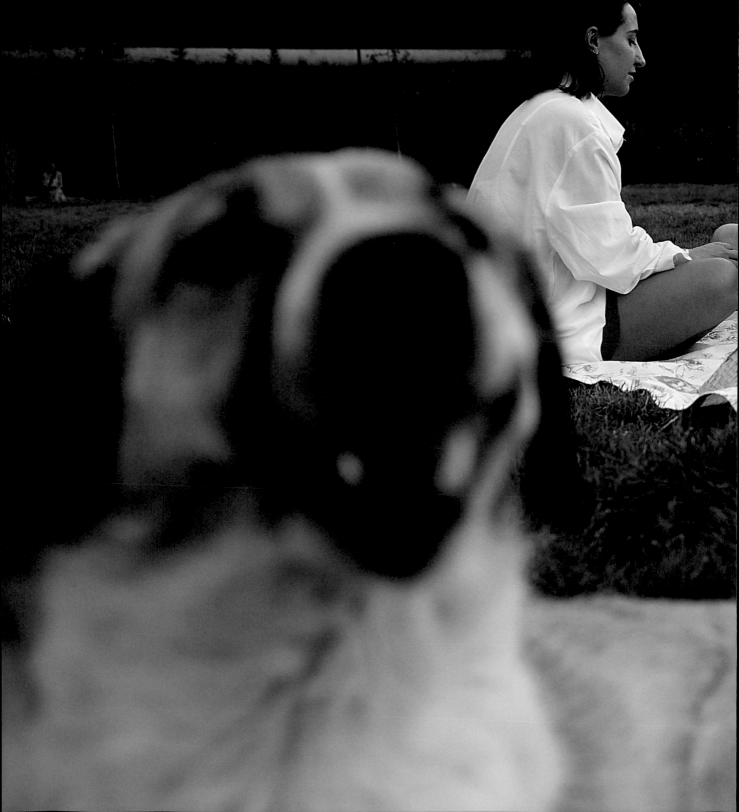

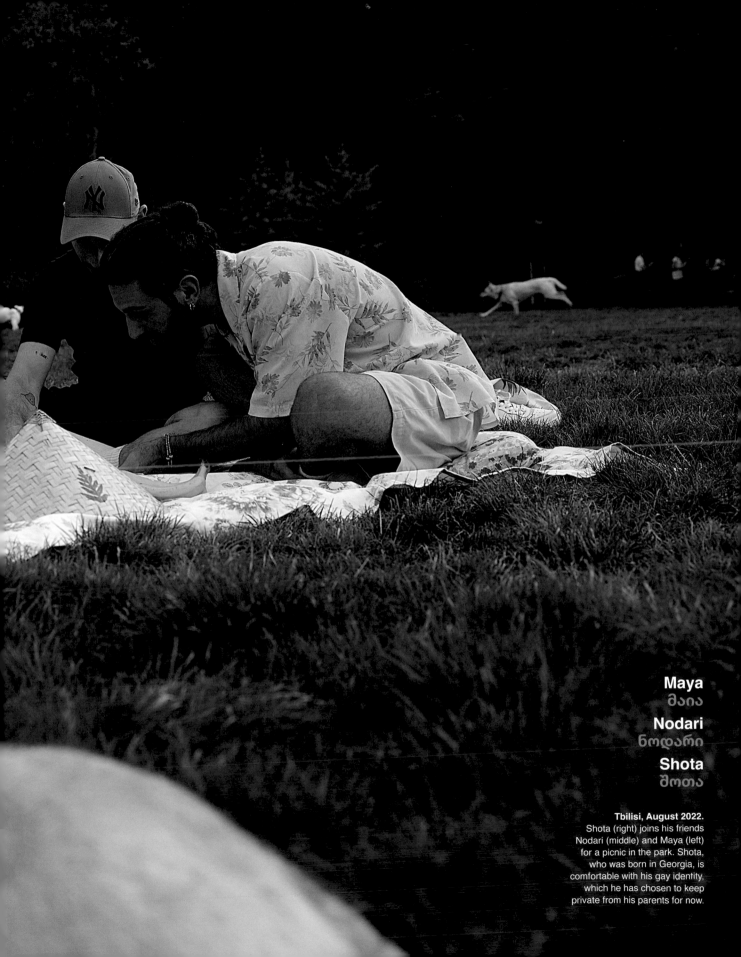

Maya
მაია
Nodari
ნოდარი
Shota
შოთა

Tbilisi, August 2022.
Shota (right) joins his friends
Nodari (middle) and Maya (left)
for a picnic in the park. Shota,
who was born in Georgia, is
comfortable with his gay identity,
which he has chosen to keep
private from his parents for now.

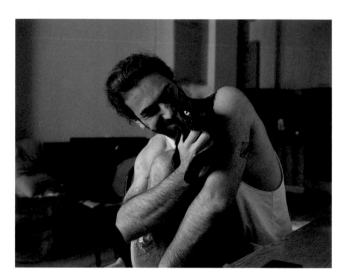

Shota
შოთა

Tbilisi, August 2022.
Shota in the kitchen of his
shared apartment, which he
rents along with two friends.

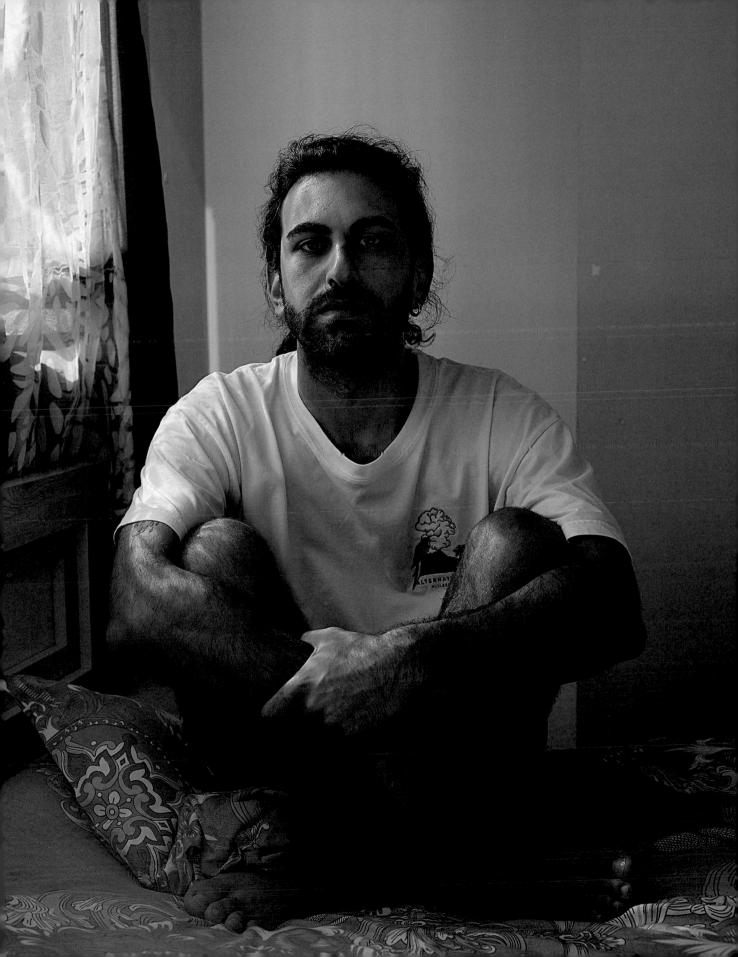

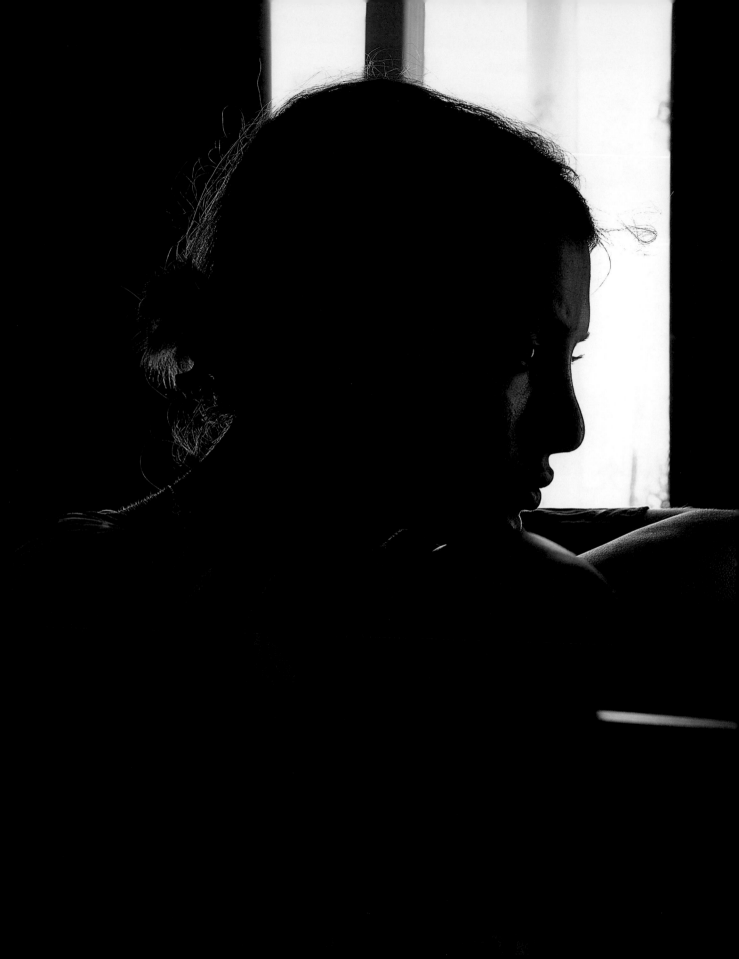

Sofi
სოფი

Batumi, August 2022.
Sofi identifies as a trans-
gender woman and holds
dual Georgian and Russian
citizenship. Fortunately,
Sofi's family members are
aware of and embrace
her true identity.

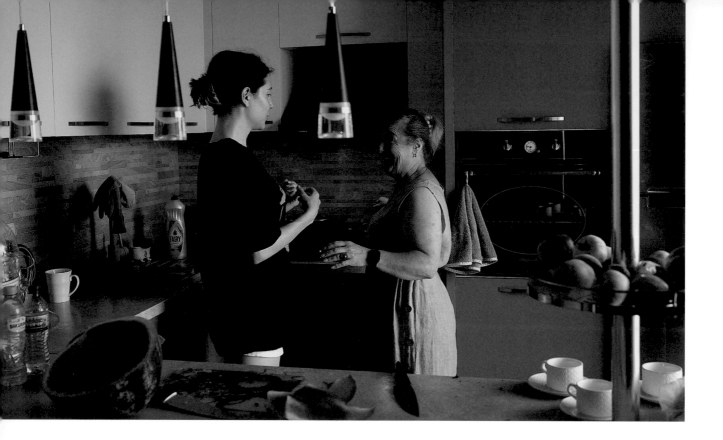

Batumi, August 2022. Sofi (left) stands alongside her mother, Naira (right), in their kitchen. Despite the challenges they face, Naira has made the difficult decision to distance herself from her siblings due to their refusal to accept Sofi.

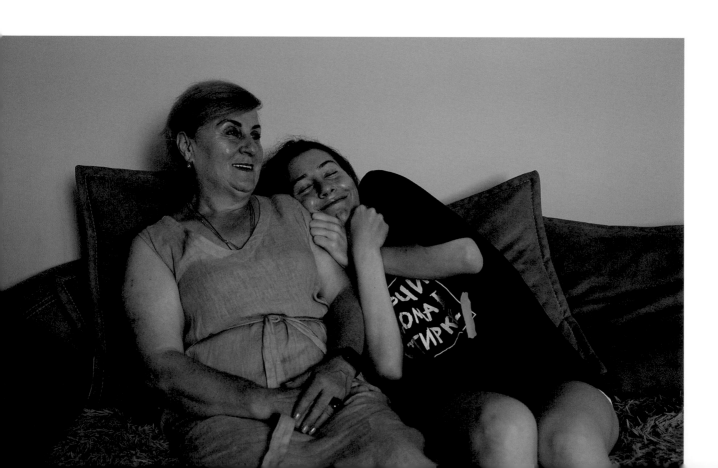

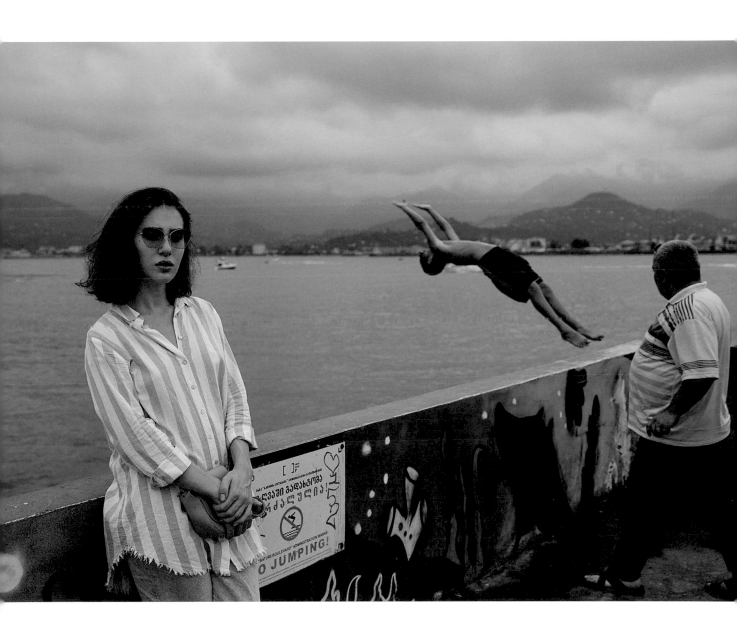

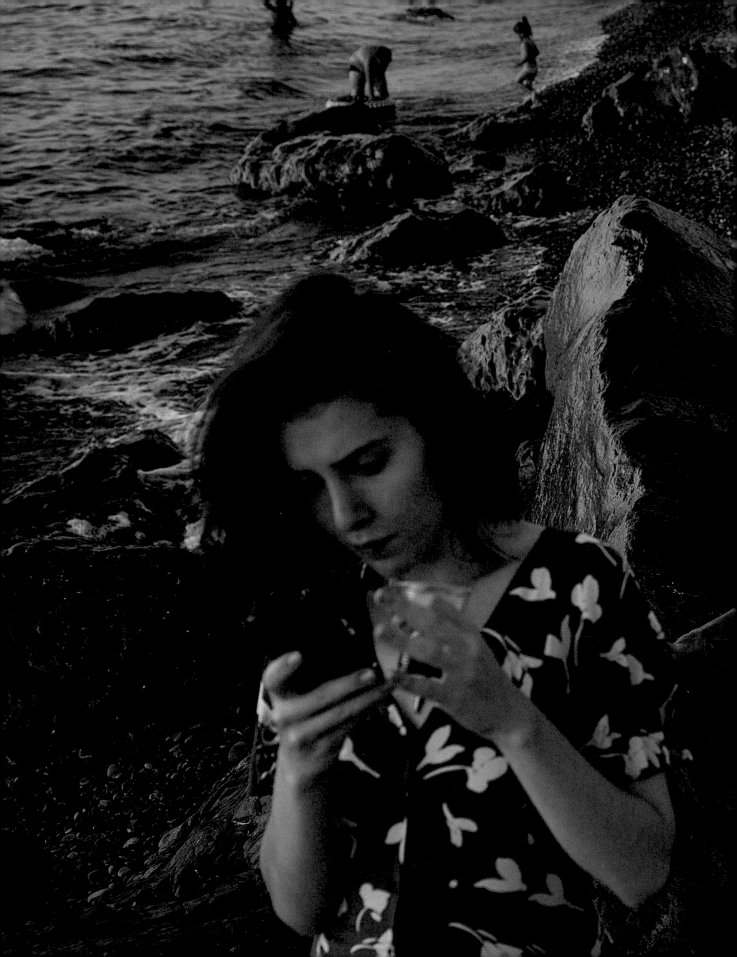

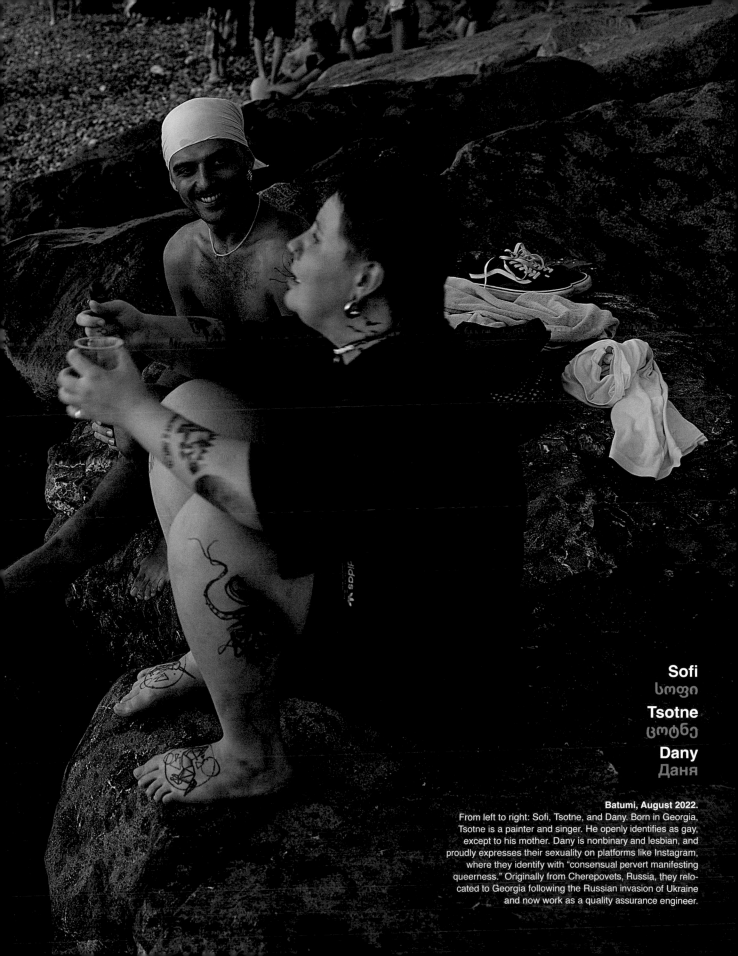

Sofi
სოფი

Tsotne
ცოტნე

Dany
Даня

Batumi, August 2022.
From left to right: Sofi, Tsotne, and Dany. Born in Georgia,
Tsotne is a painter and singer. He openly identifies as gay,
except to his mother. Dany is nonbinary and lesbian, and
proudly expresses their sexuality on platforms like Instagram,
where they identify with "consensual pervert manifesting
queerness." Originally from Cherepovets, Russia, they relo-
cated to Georgia following the Russian invasion of Ukraine
and now work as a quality assurance engineer.

Tsotne
ცოტნე

Batumi, August 2022.
Tsotne acknowledges the ongoing struggles encountered by the LGBTQ community in Georgia, where prejudice still exists, but he hopes eventually to see a more open-minded society. He often compares the level of acceptance for gay people in Georgia to that in more LGBTQ-friendly countries such as Spain and Germany, noting that while progress is being made, Georgia still has a long way to go even when compared to many of its Eastern European neighbors.

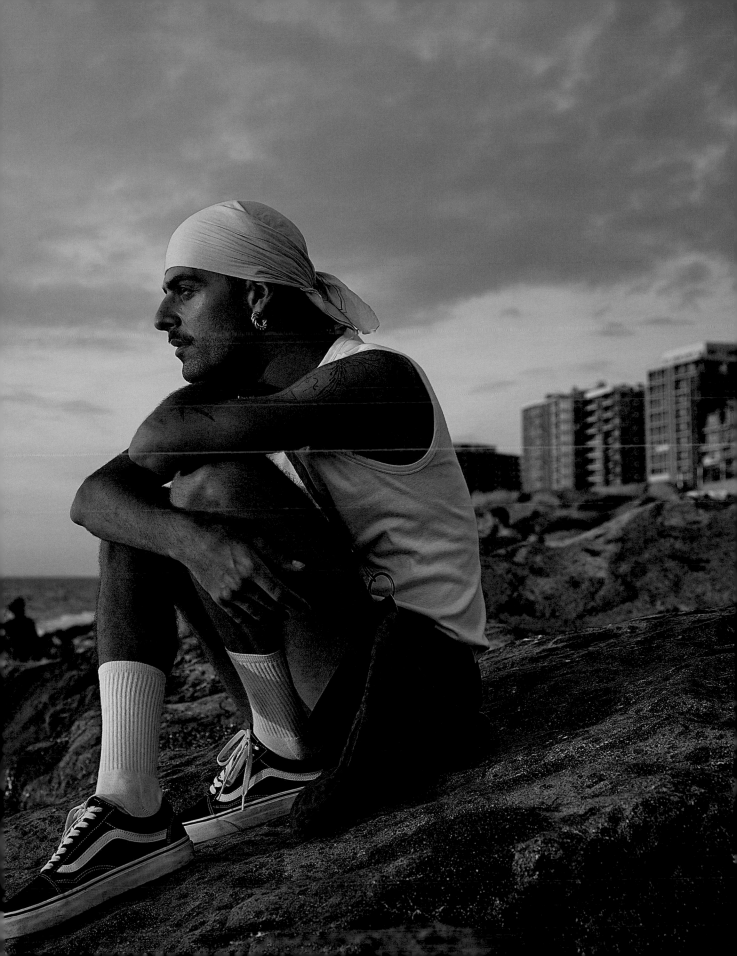

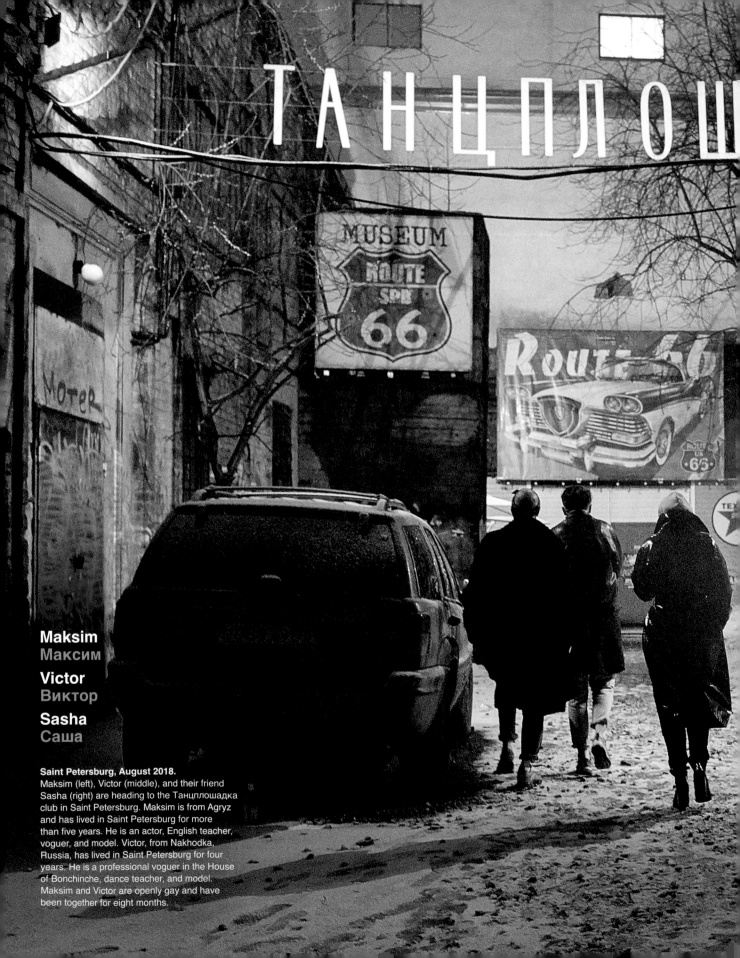

Maksim
Максим

Victor
Виктор

Sasha
Саша

Saint Petersburg, August 2018.
Maksim (left), Victor (middle), and their friend
Sasha (right) are heading to the Танцплошадка
club in Saint Petersburg. Maksim is from Agryz
and has lived in Saint Petersburg for more
than five years. He is an actor, English teacher,
voguer, and model. Victor, from Nakhodka,
Russia, has lived in Saint Petersburg for four
years. He is a professional voguer in the House
of Bonchinche, dance teacher, and model.
Maksim and Victor are openly gay and have
been together for eight months.

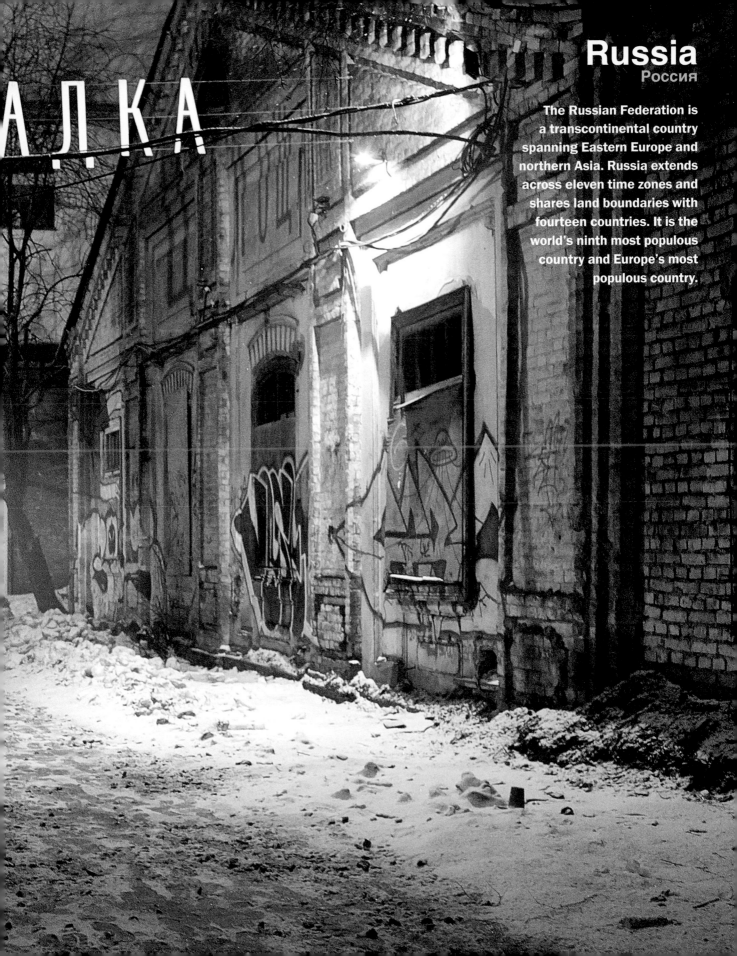

Russia
Россия

The Russian Federation is a transcontinental country spanning Eastern Europe and northern Asia. Russia extends across eleven time zones and shares land boundaries with fourteen countries. It is the world's ninth most populous country and Europe's most populous country.

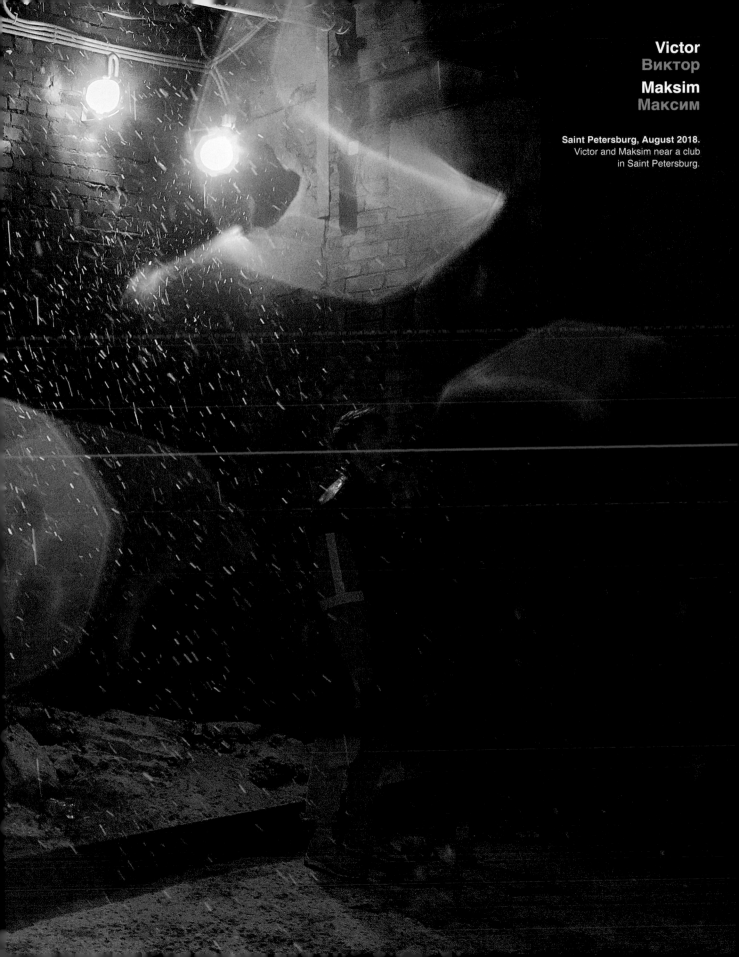

Victor
Виктор

Maksim
Максим

Saint Petersburg, August 2018.
Victor and Maksim near a club
in Saint Petersburg.

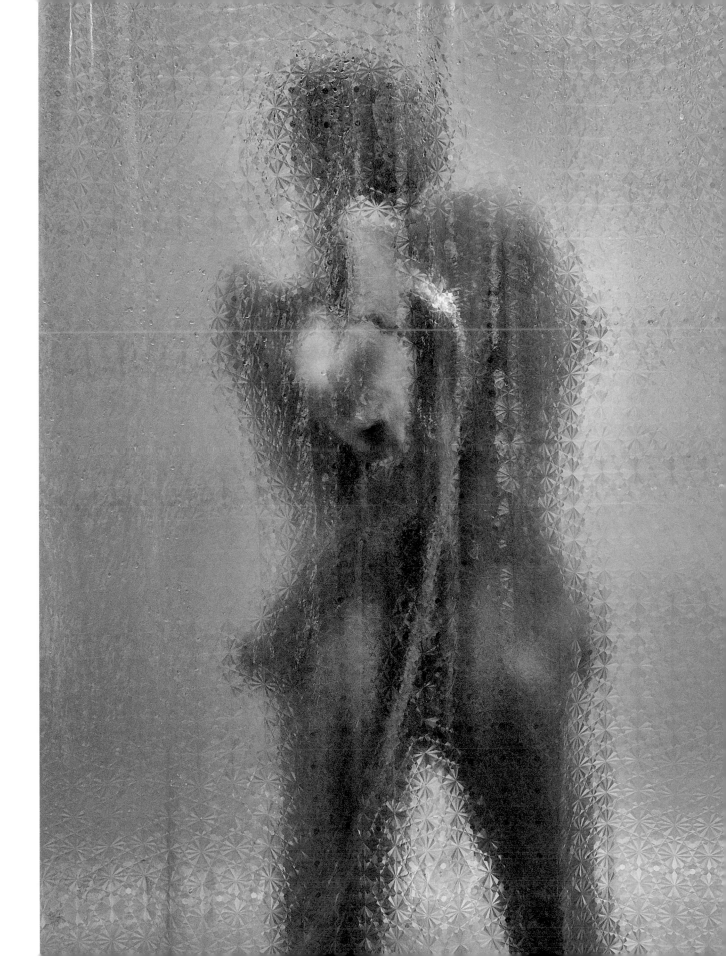

Lisa
Лиза

Obninsk/Moscow, April 2019.
Lisa is a writer and the host
of the podcast *I Want It So
Badly* ("Хочу не могу"). She
is also the co-publisher of
the literary magazine *Not
Knowing* ("Незнание").

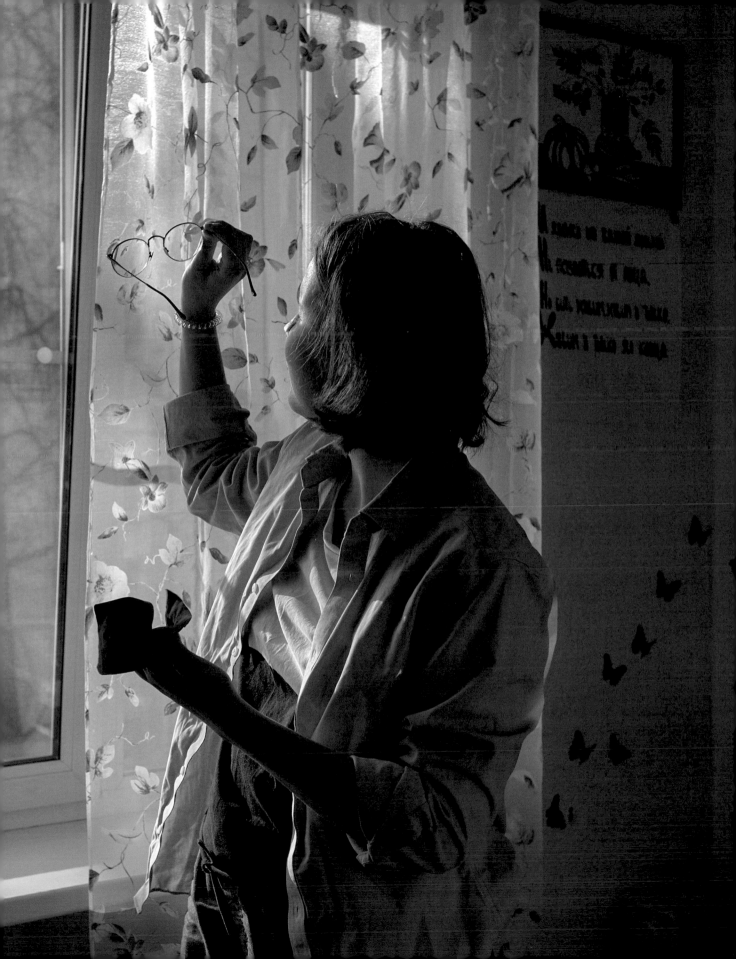

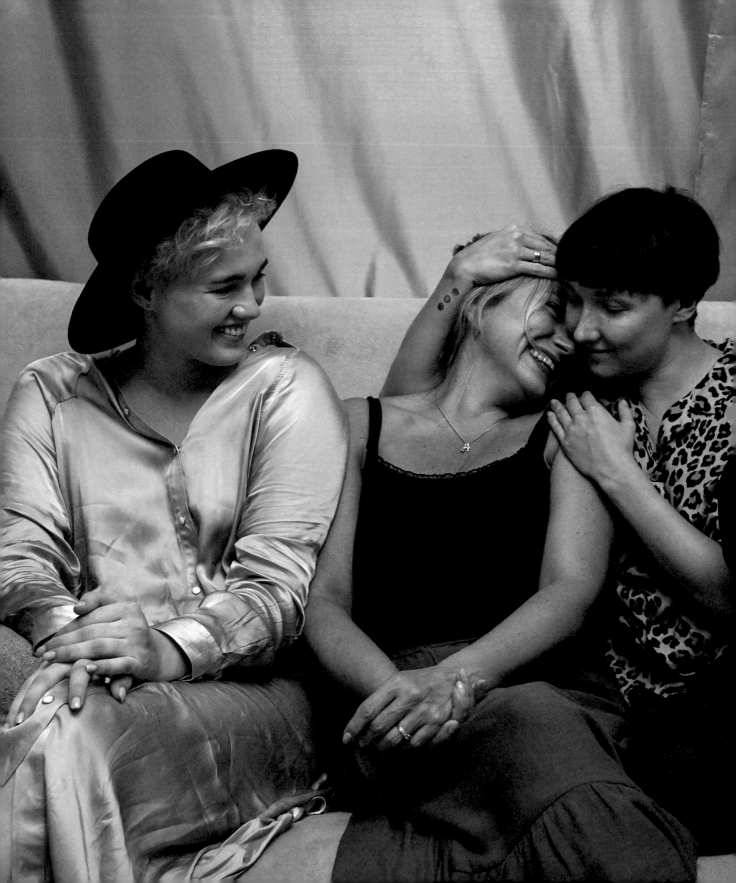

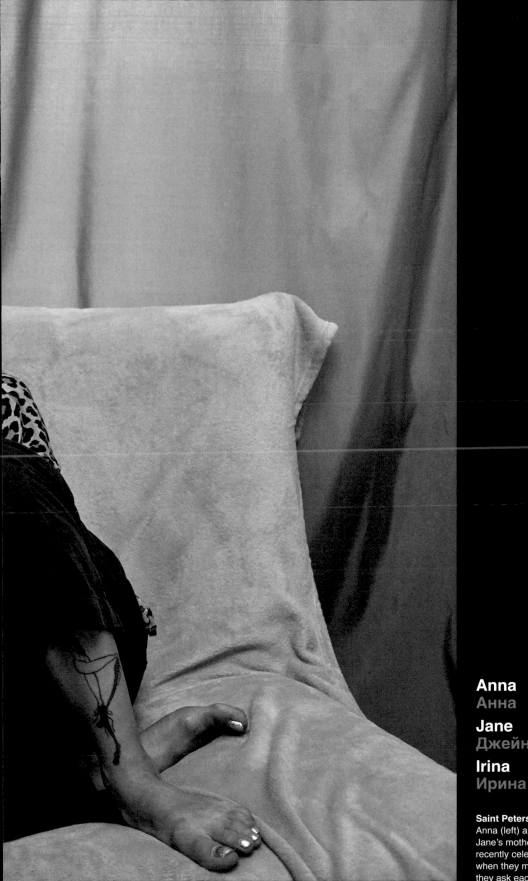

Anna
Анна

Jane
Джейн

Irina
Ирина

Saint Petersburg, July 2018.
Anna (left) and Jane (right) sit on the sofa with
Jane's mother (center), Irina. Anna and Jane
recently celebrated the one-year anniversary of
when they met. Every day at 4:16 in the afternoon,
they ask each other if they want to get married,

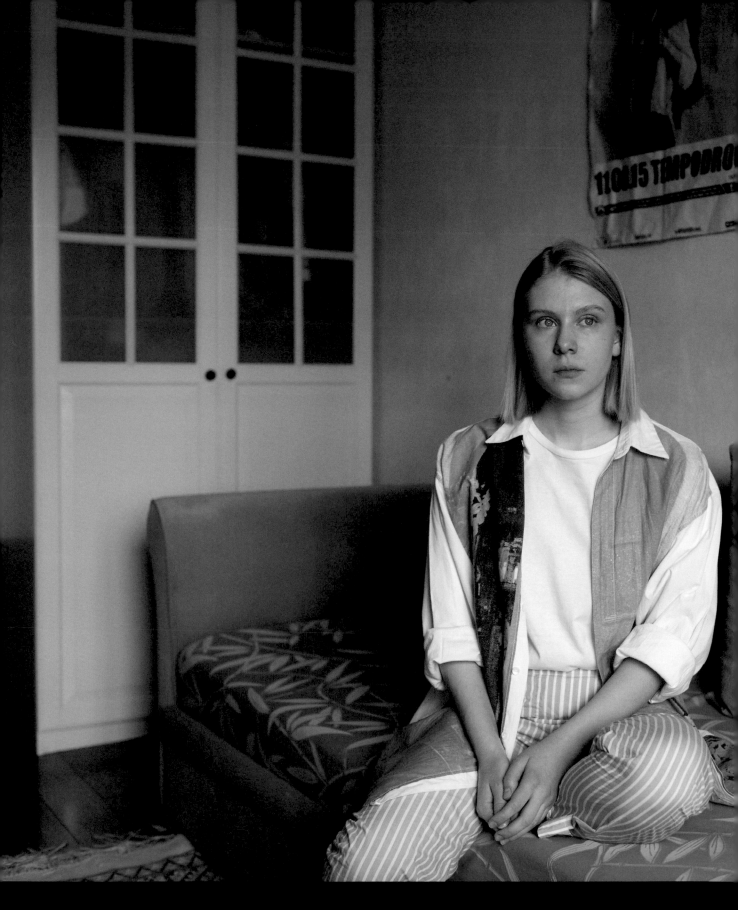

Arina
Арина

Moscow, April 2019.
Arina is an openly gay visual artist.

Elena
Елена

Moscow, April 2019.
Elena examines a private archive
of LGBTQ media issued in Russia
from the 1990s.

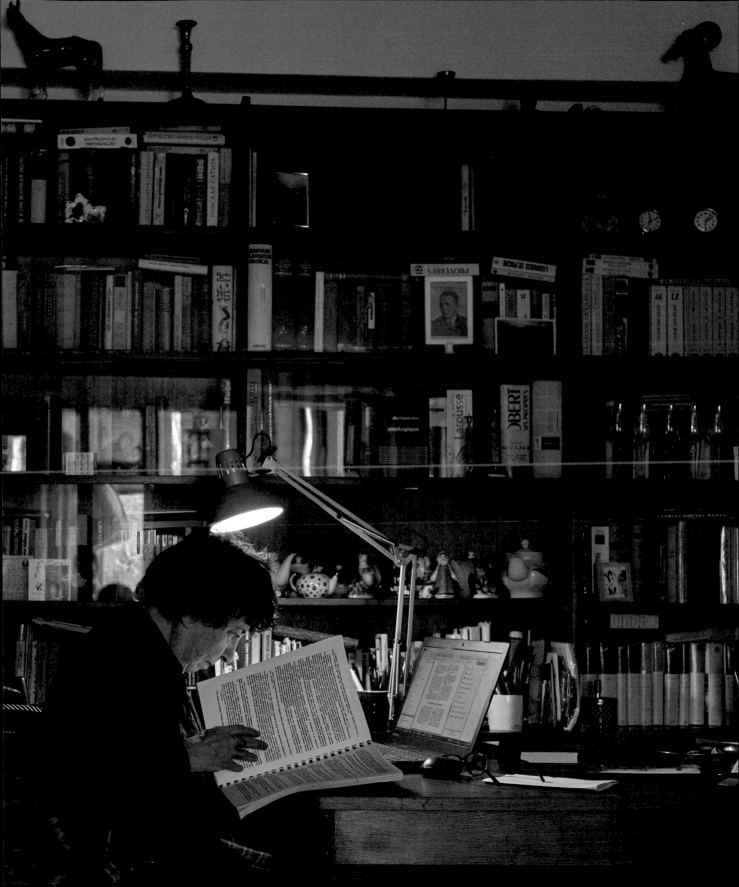

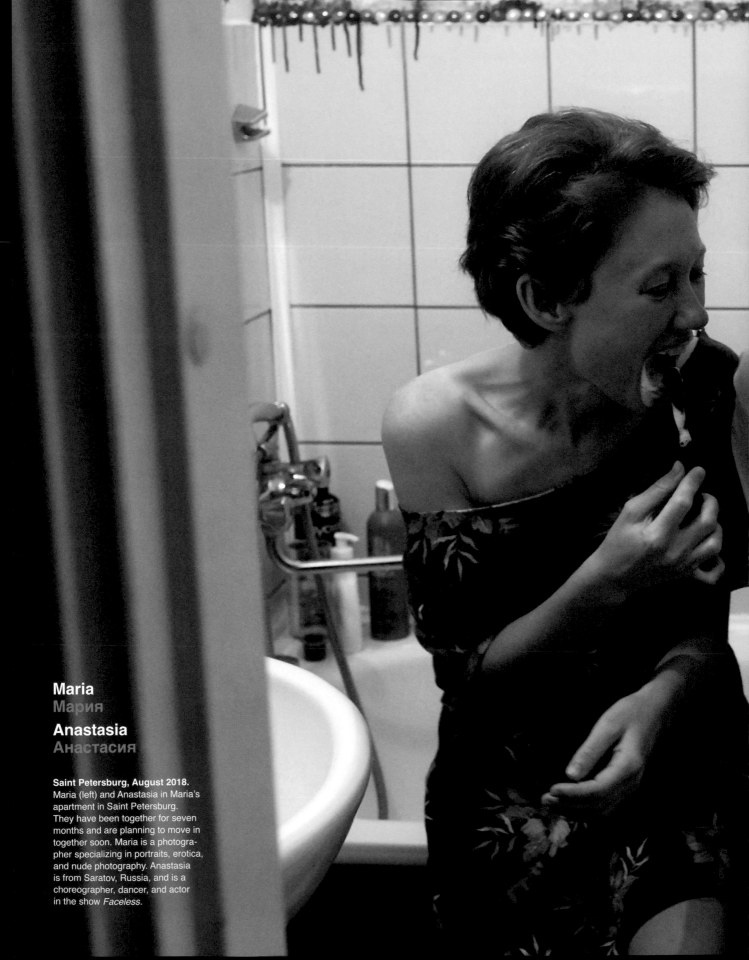

Maria
Мария

Anastasia
Анастасия

Saint Petersburg, August 2018.
Maria (left) and Anastasia in Maria's apartment in Saint Petersburg. They have been together for seven months and are planning to move in together soon. Maria is a photographer specializing in portraits, erotica, and nude photography. Anastasia is from Saratov, Russia, and is a choreographer, dancer, and actor in the show *Faceless*.

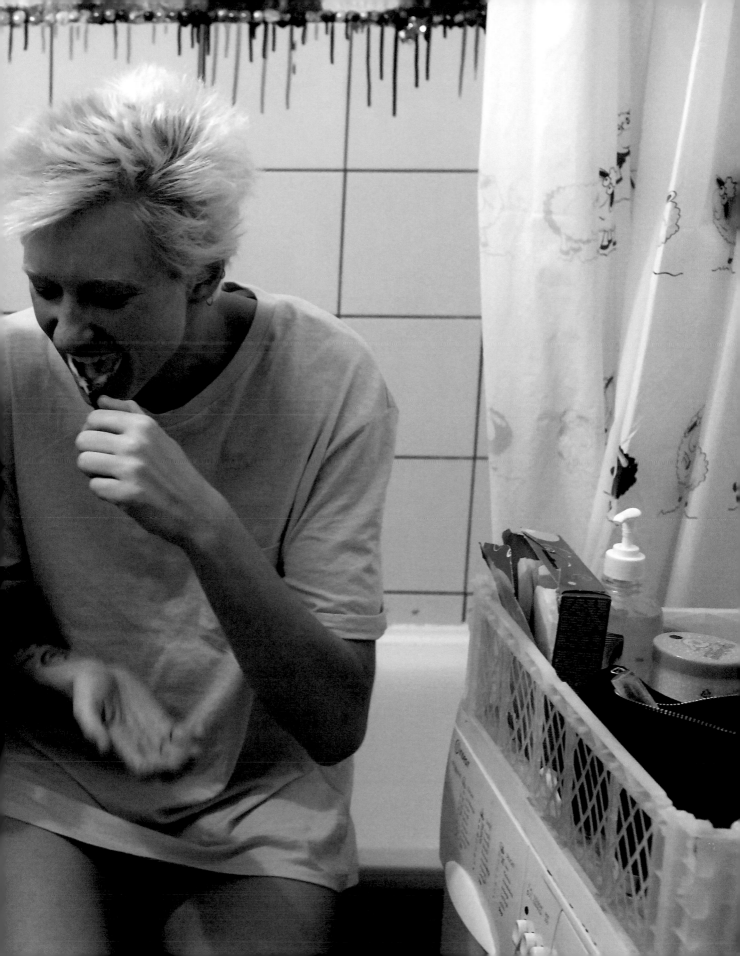

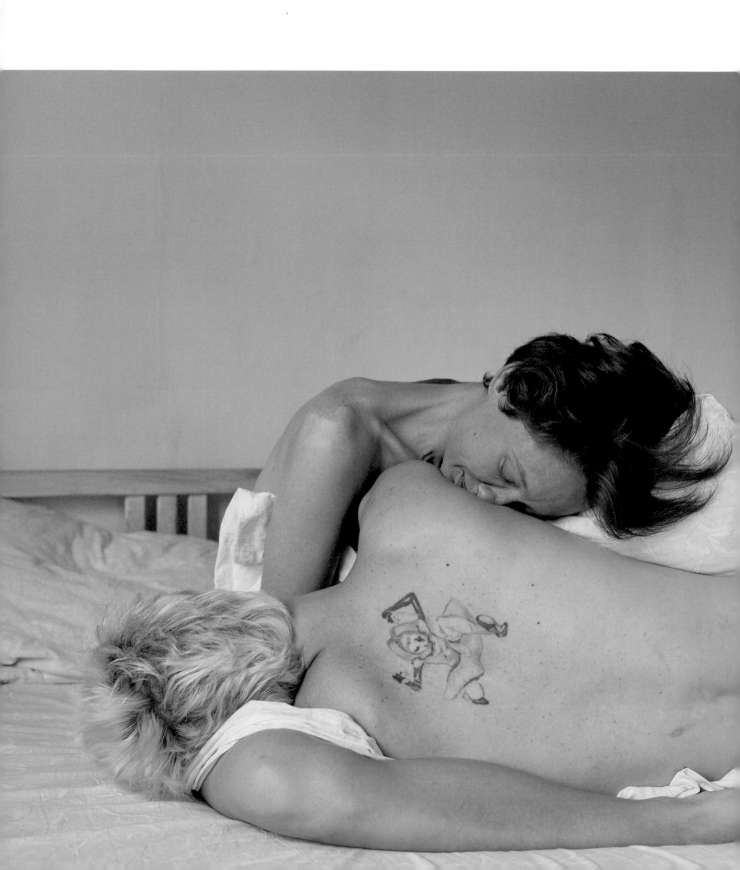

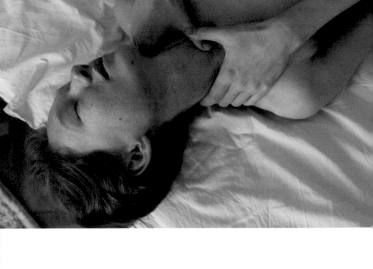

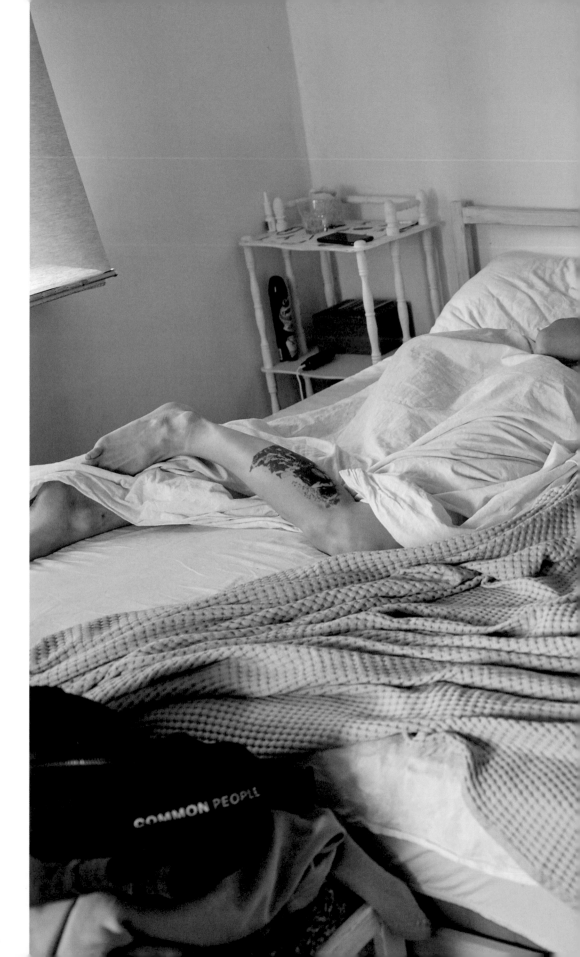

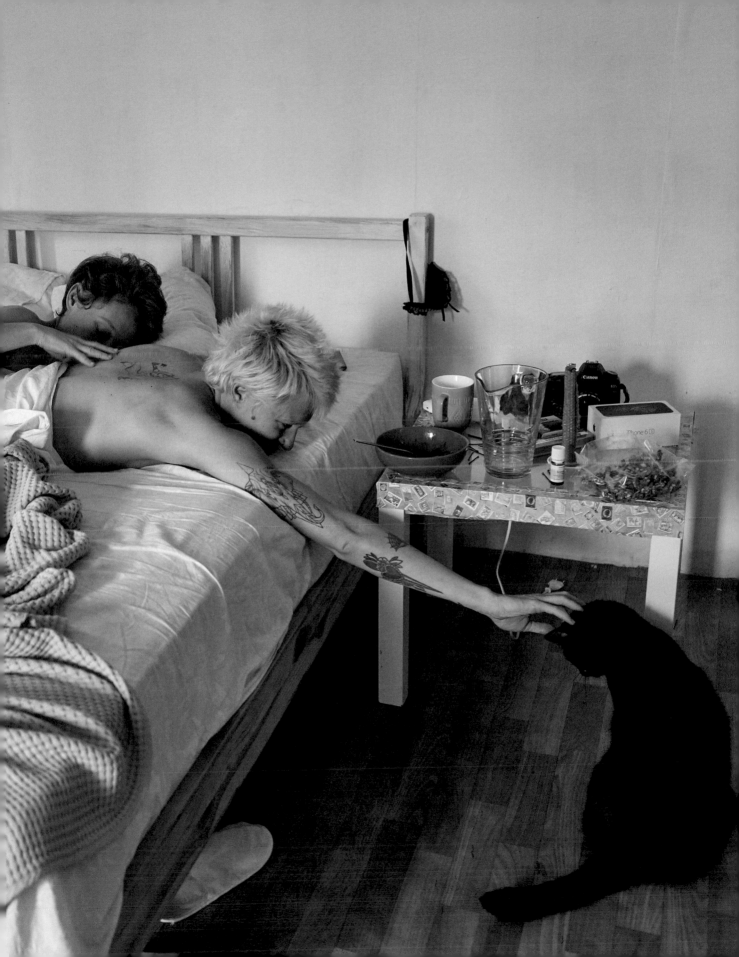

Konstantin
Константин

Moscow, April 2019.
Konstantin Prima relaxes in his bathtub. He earns a living by impersonating Alla Pugacheva, a renowned Russian singer.

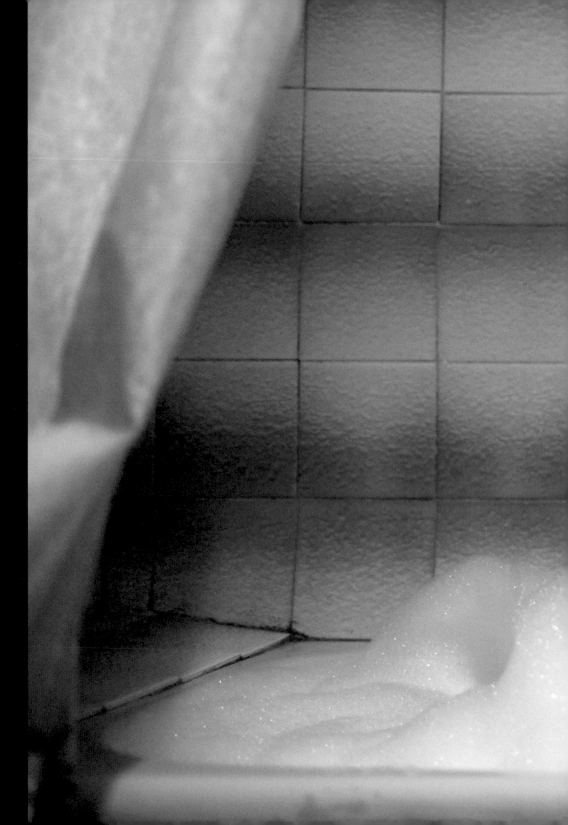

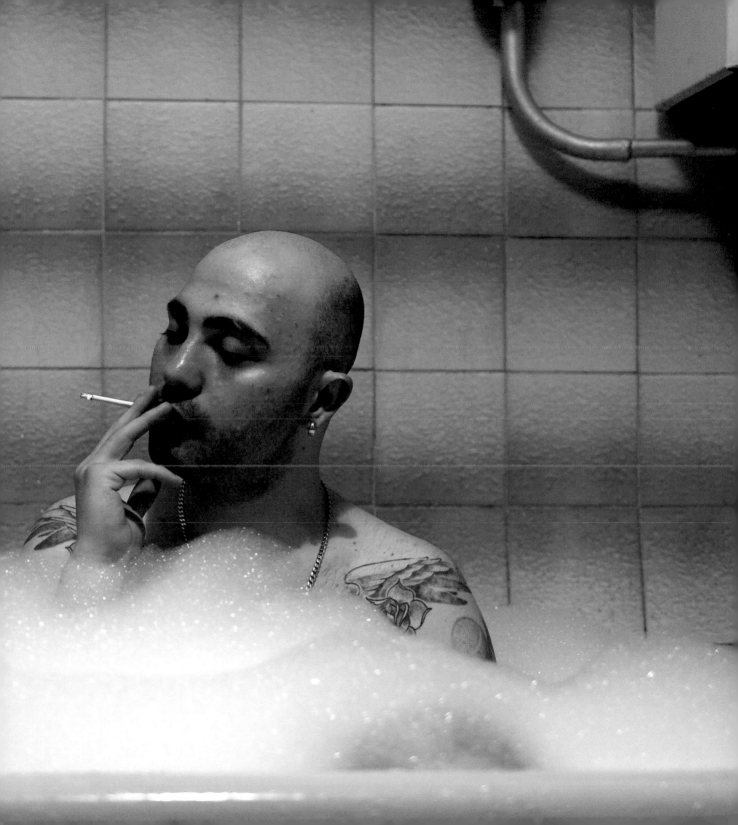

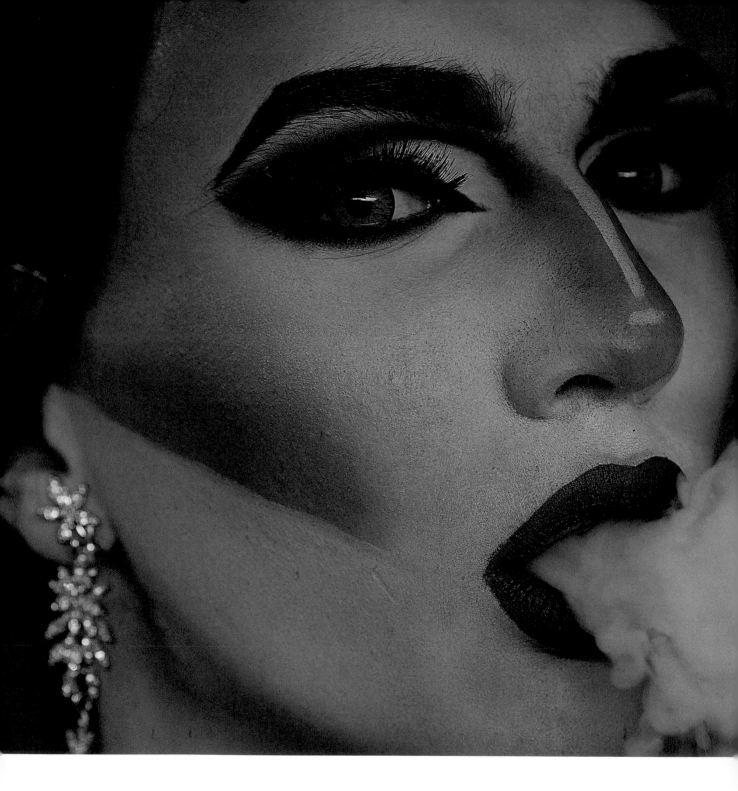

Vanessa
Ванесса

Saint Petersburg, August 2018.
Nikolay, a drag performer known as Vanessa Shy, in the changing
room of the gay club Central Station SPB before her performance.

Saint Petersburg.
A couple at the Blue Oyster Bar, one of
the most famous gay clubs in the city.

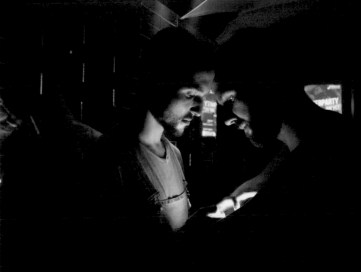

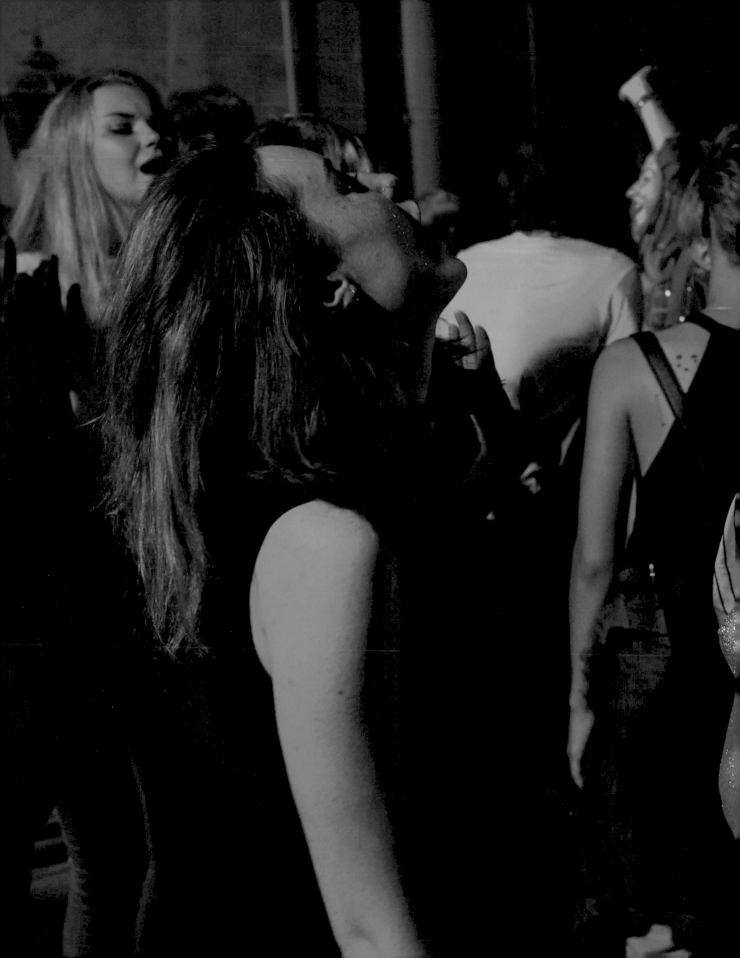

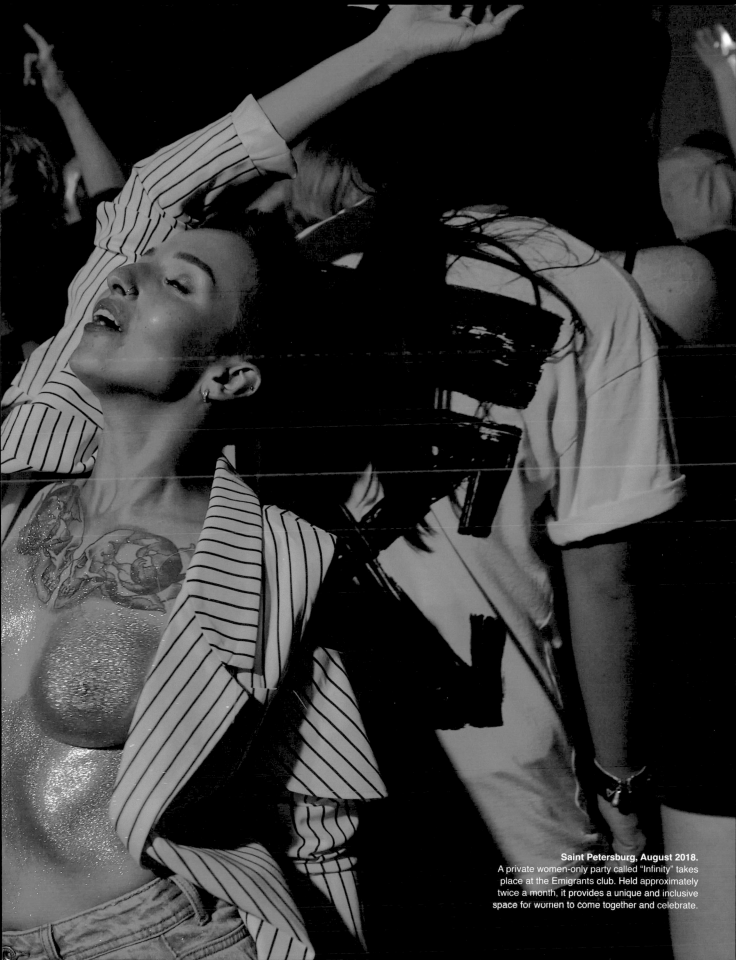

Saint Petersburg, August 2018.
A private women-only party called "Infinity" takes place at the Emigrants club. Held approximately twice a month, it provides a unique and inclusive space for women to come together and celebrate.

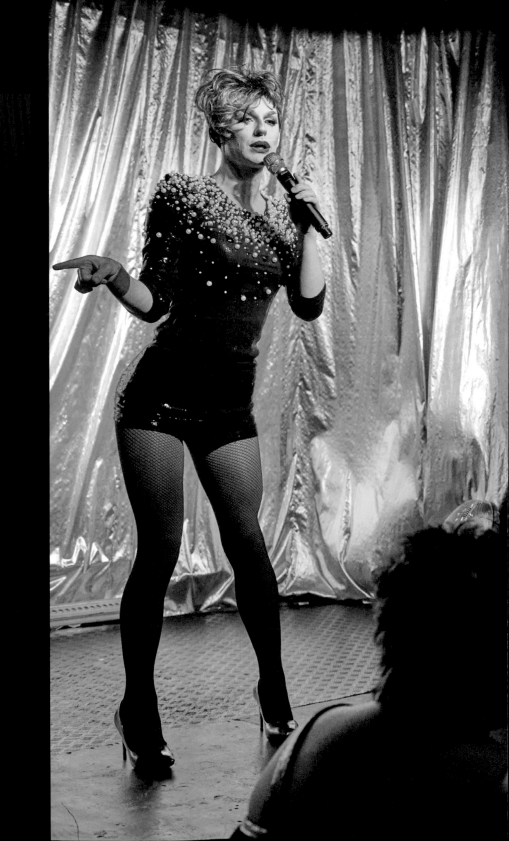

Miss Tekila
Мисс Текила

Saint Petersburg, May 2018.
Alexandr, a drag performer
known as Miss Tekila, performs
at Central Station SPB. He has
lived in Saint Petersburg for
twelve years after coming from
Montschegorsk, Russia. He is

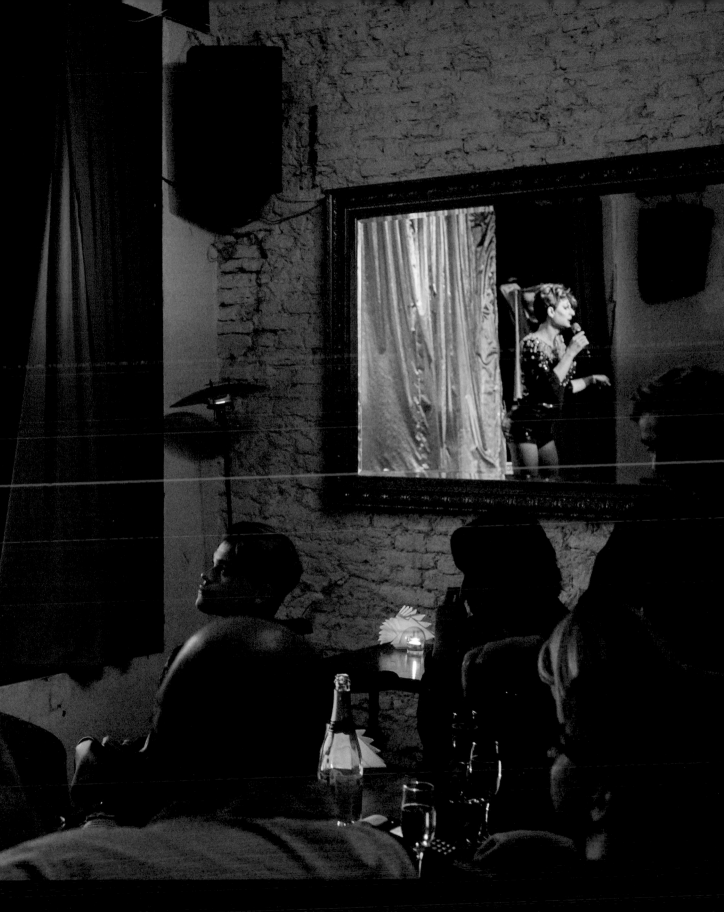

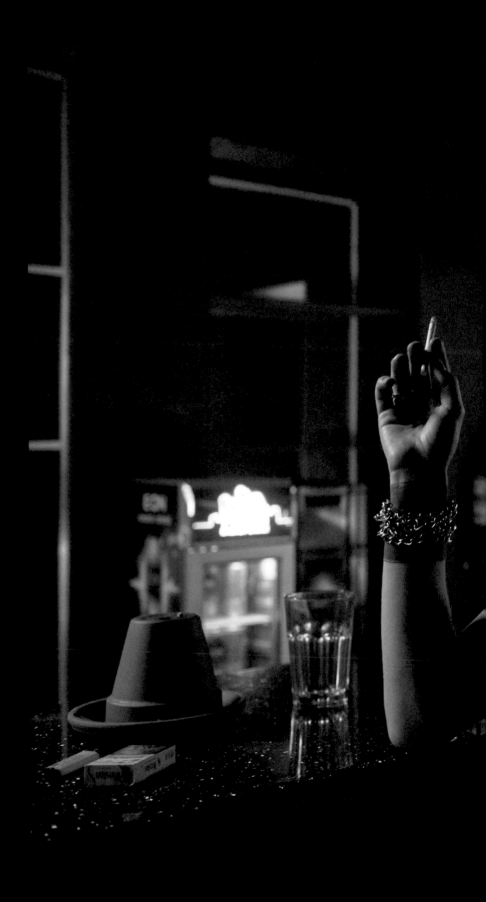

Saint Petersburg, May 2018.
Miss Tekila takes a break at Central
Station SPB after her performance.

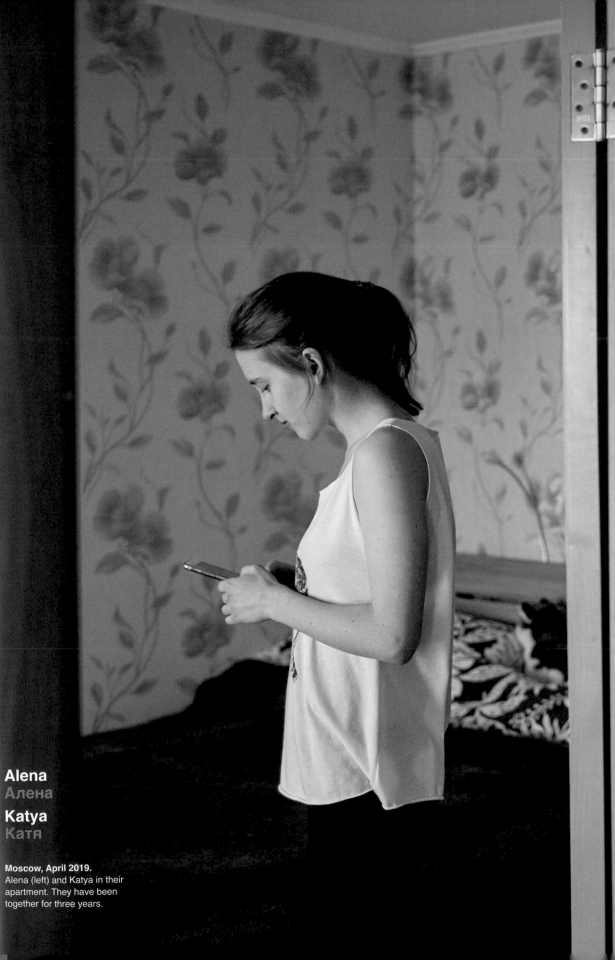

Alena
Алена

Katya
Катя

Moscow, April 2019.
Alena (left) and Katya in their
apartment. They have been
together for three years.

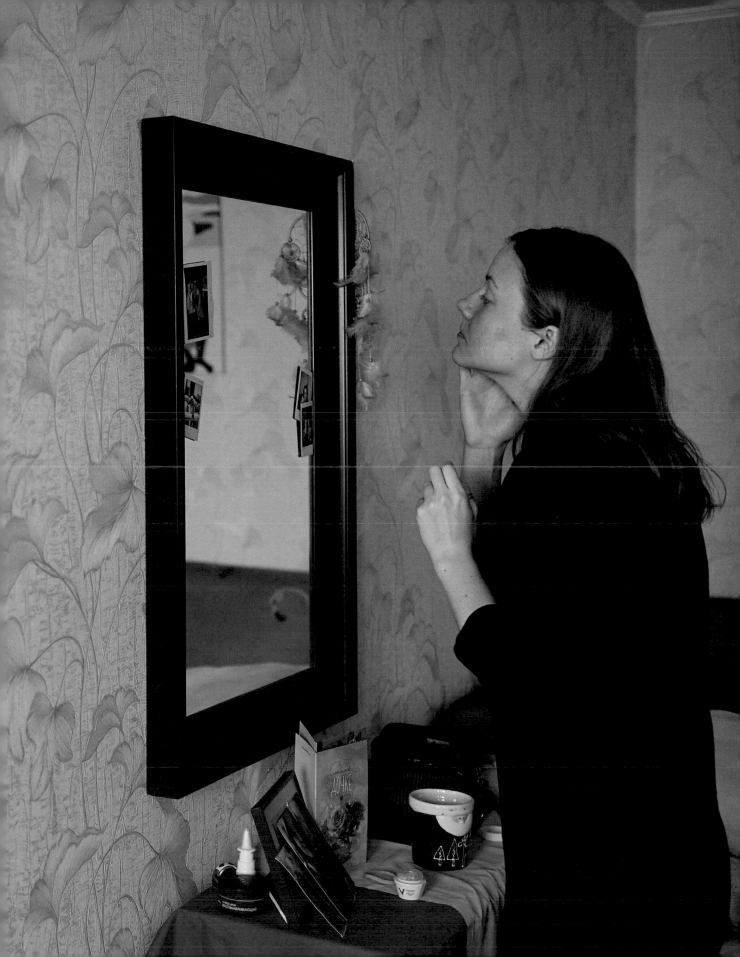

Alexandra
Александра

Saint Petersburg, August 2018.
Alexandra is originally from
Samara, Russia, but has lived in
Saint Petersburg for three years.
She is currently single and works
as a bartender.

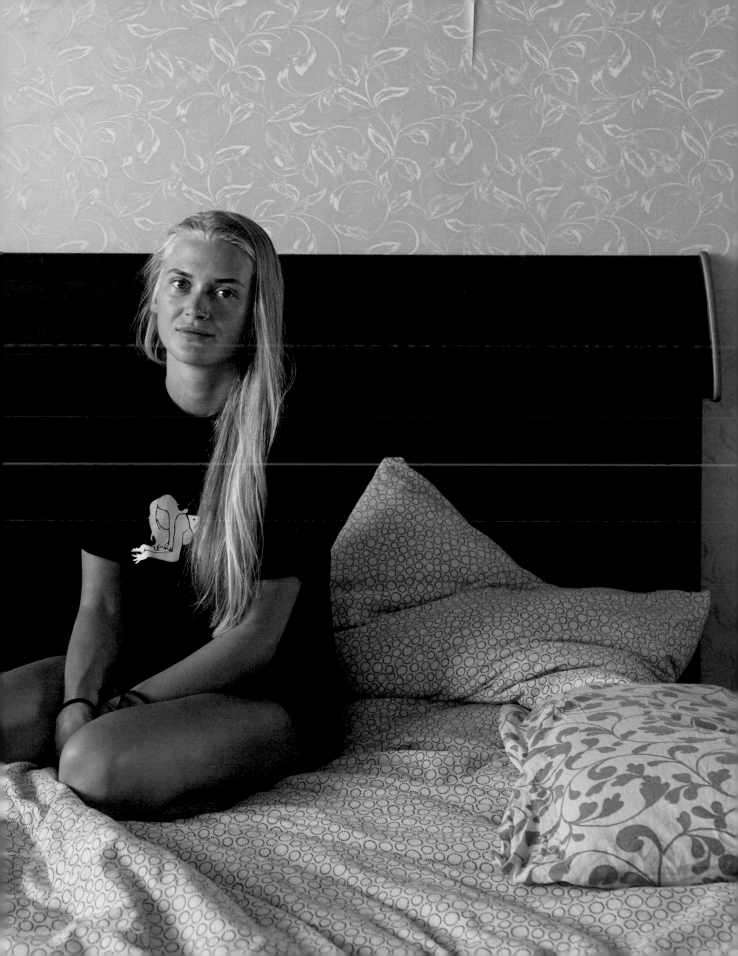

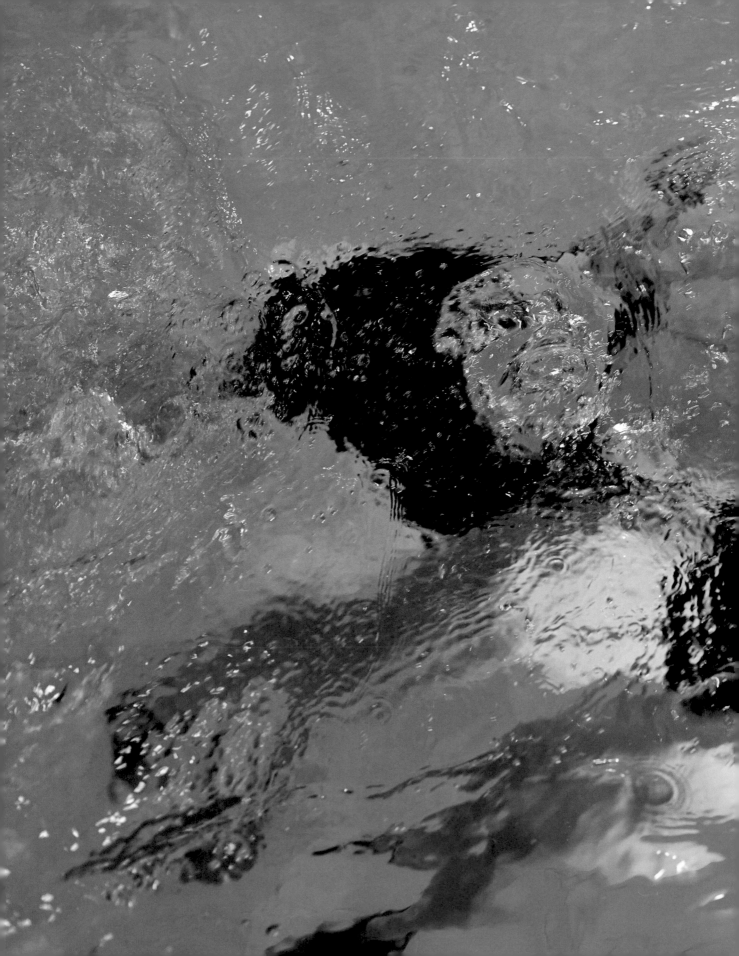

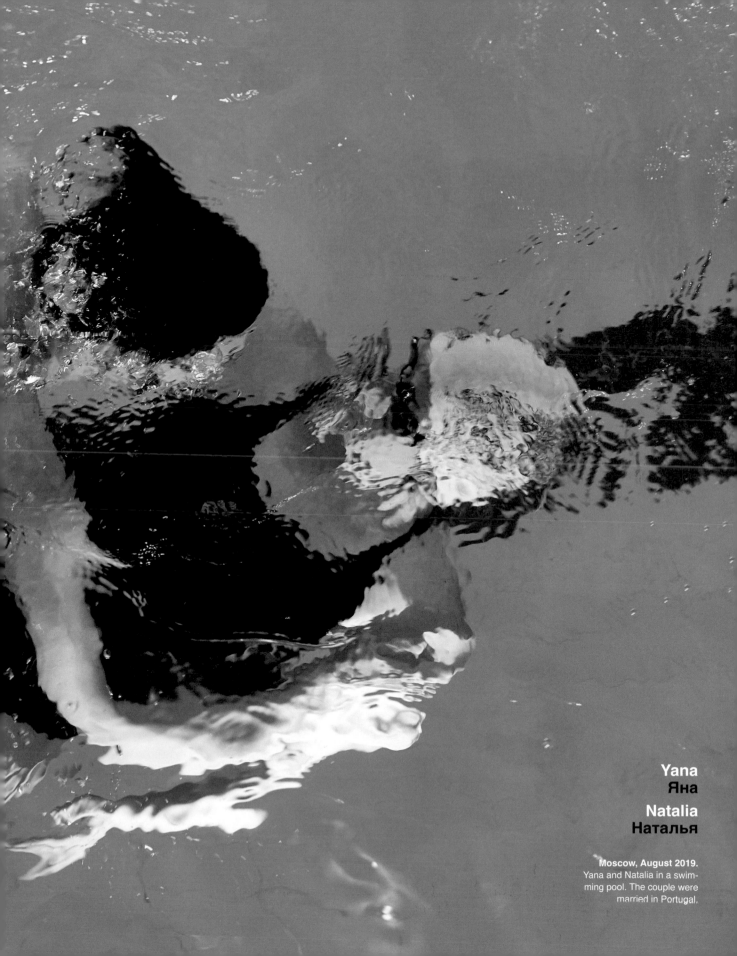

Yana
Яна

Natalia
Наталья

Moscow, August 2019.
Yana and Natalia in a swim-
ming pool. The couple were
married in Portugal.

Kazan, February 2022. A view of central Kazan as seen from Epiphany Cathedral's belltower.

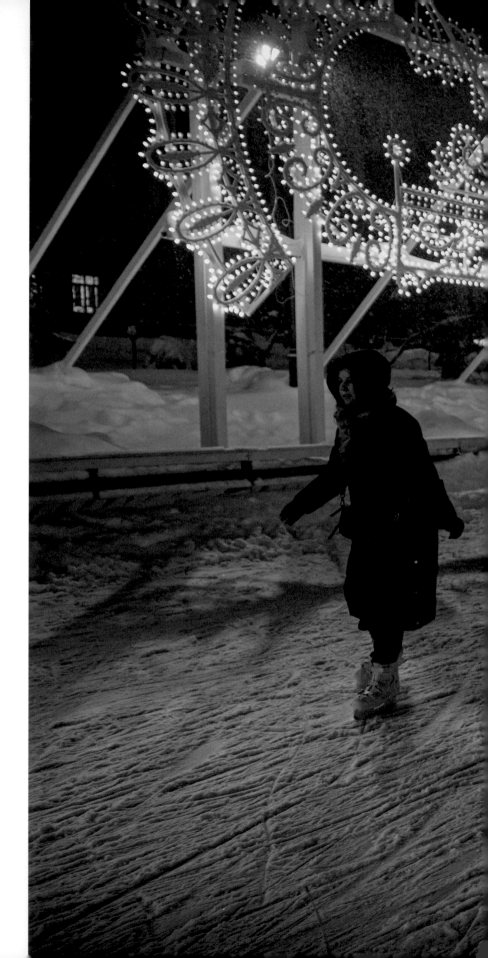

Ksenia
Ксения

Snezhana
Снежана

Kazan, February 2022.
Ksenia and Snezhana at an
outdoor skating rink. Ksenia
works as a senior graphic
designer in a digital agency.
She is also a freelance illustra-
tor and art director. Snezhana
is an iOS developer. She is
openly gay, while Ksenia has
not yet come out to her family.
They have been together for
three and a half years and
share a dream of moving to
the United States.

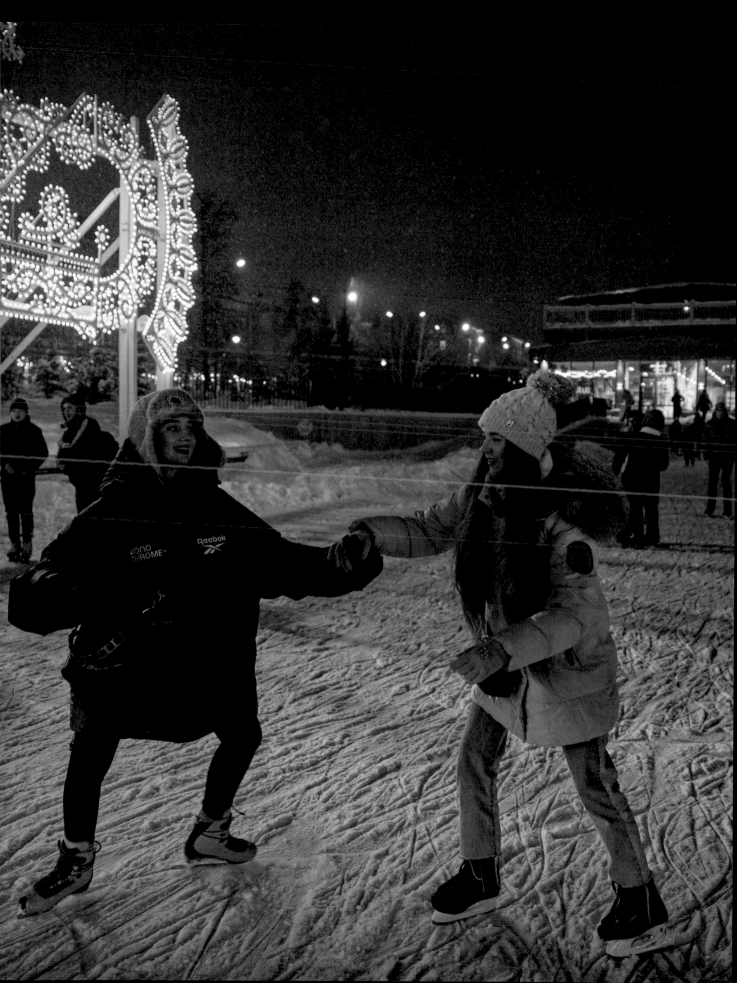

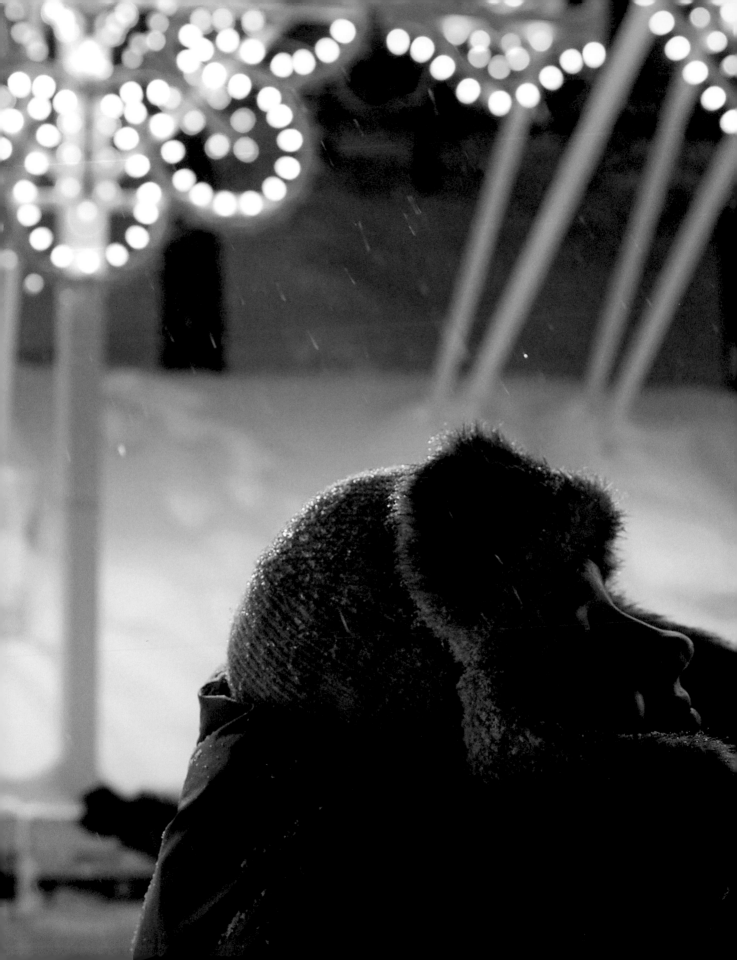

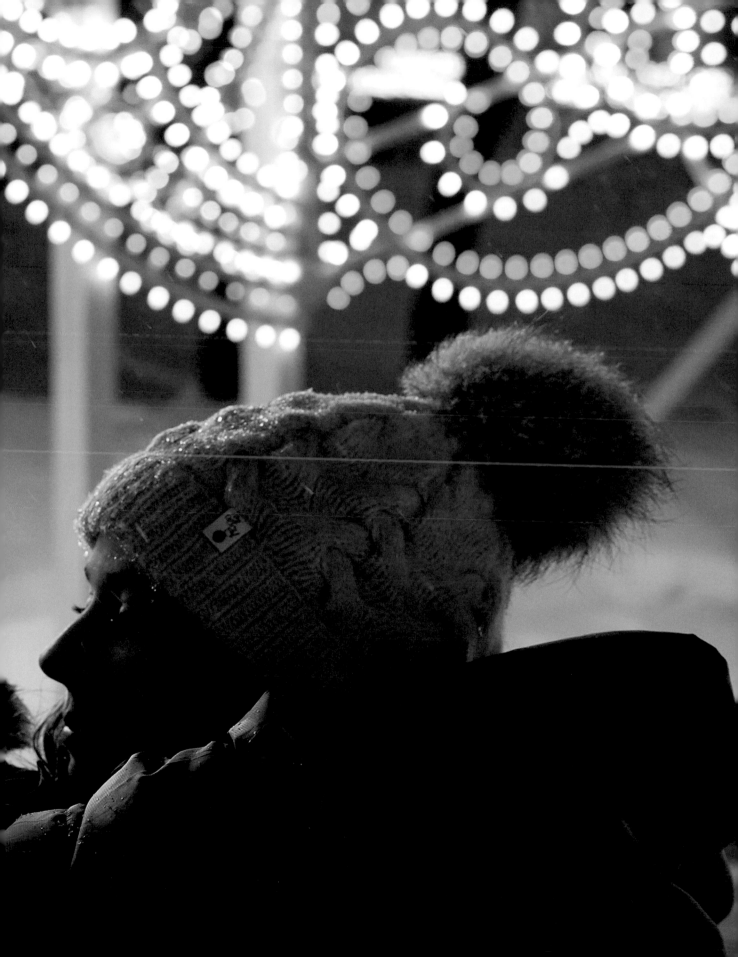

Kazan, February 2022.

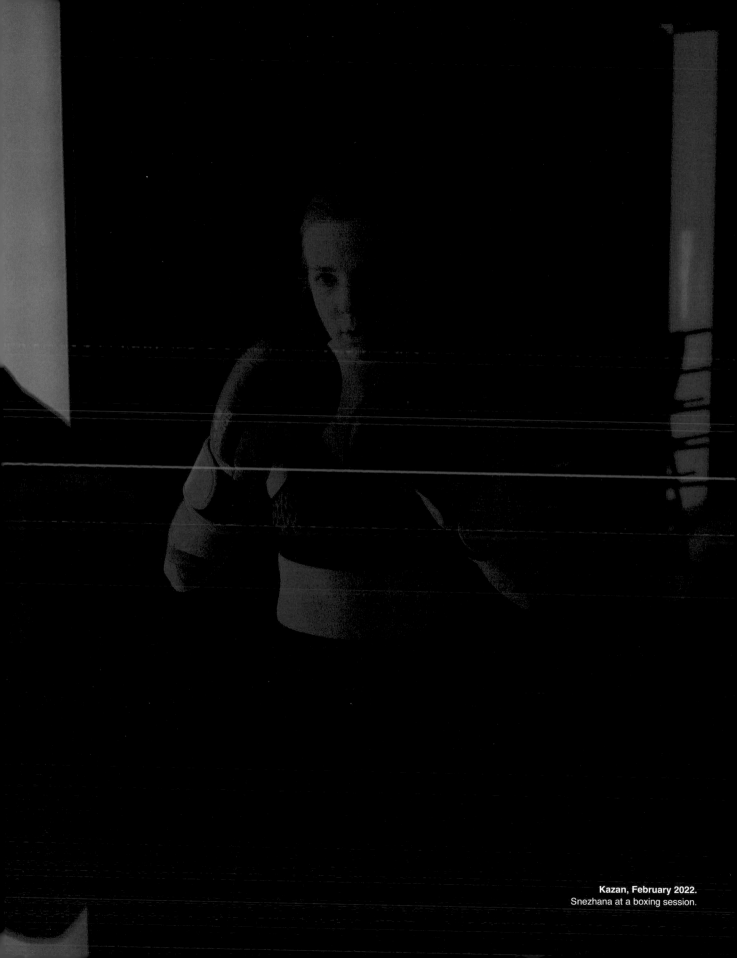

Kazan, February 2022.
Snezhana at a boxing session.

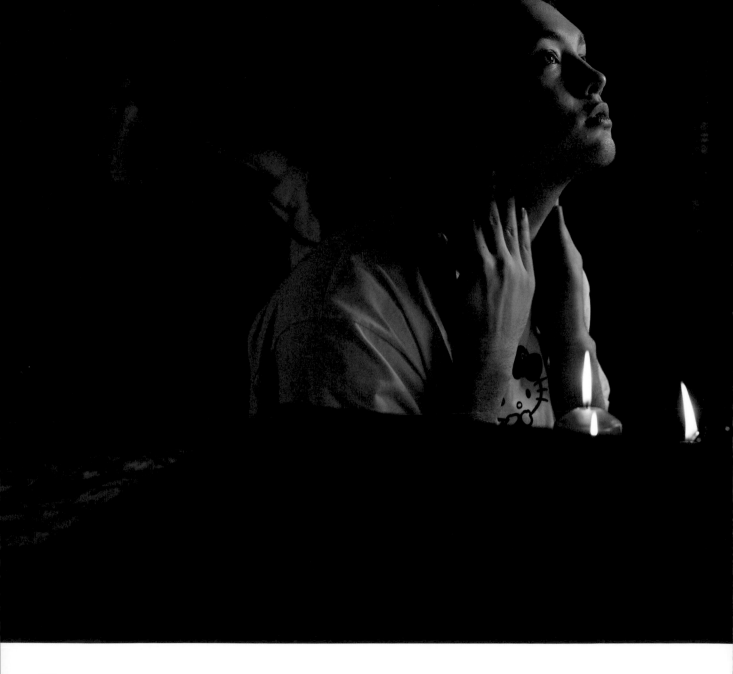

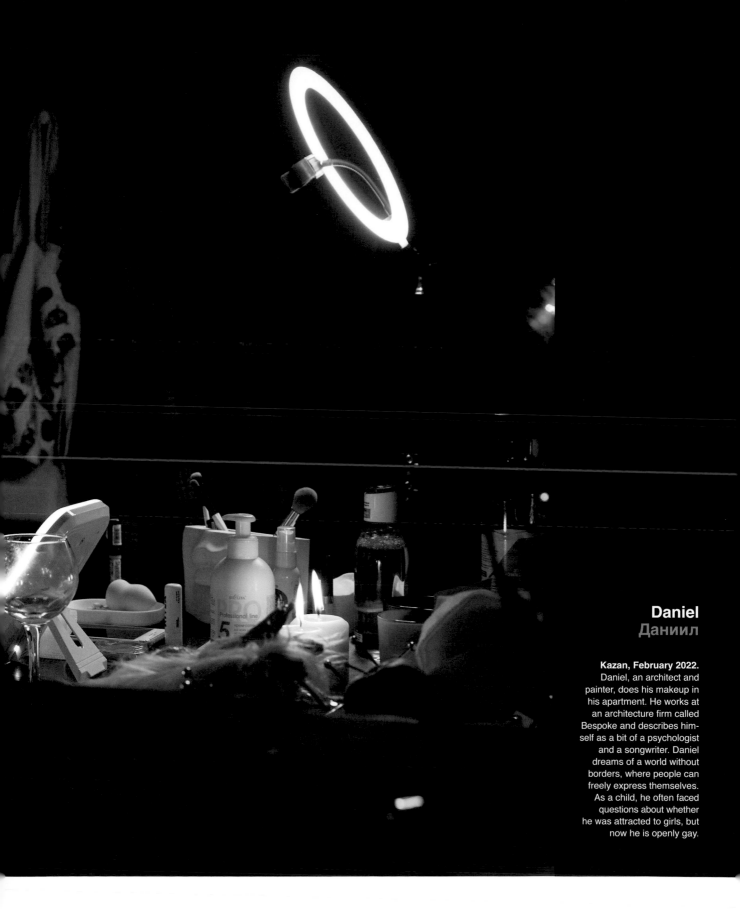

Daniel
Даниил

Kazan, February 2022.
Daniel, an architect and painter, does his makeup in his apartment. He works at an architecture firm called Bespoke and describes himself as a bit of a psychologist and a songwriter. Daniel dreams of a world without borders, where people can freely express themselves. As a child, he often faced questions about whether he was attracted to girls, but now he is openly gay.

Dina
Дина

Anastasia
Анастасия

Kazan, February 2022.
Dina (right) was born in Kazan and is
bisexual. A brand designer and art director,
she is the co-founder of Femkyzlar, a
nonprofit initiative that supports feminists.
Anastasia, born in Yakutia, Russia, is a
lawyer and identifies as a lesbian. The two
met on Tinder and have been open about
their relationship ever since. Although it
was initially challenging for their parents
to accept their queerness, they now share
a loving and supportive bond. Dina and
Anastasia hope to live peacefully in their
cozy home in Kazan, although they recently
had a distressing encounter with the police,
who conducted a search of their home,
confiscating Dina's laptop and phone.

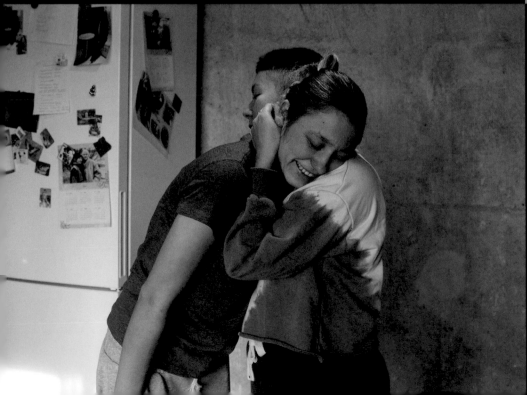

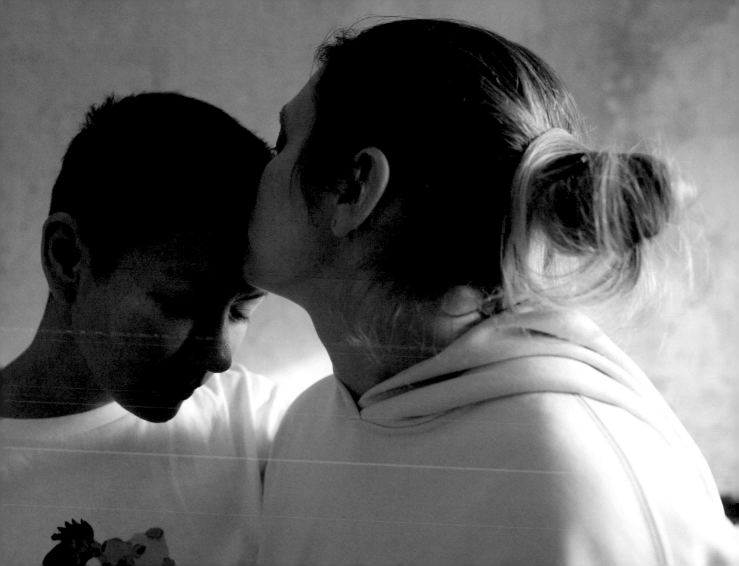

Elena
Елена

Kazan, February 2022.
Elena at a bookstore. She is
a journalist and has written
for various media outlets such
as Takie Dela, Meduza, BBC,
Afisha, Wonderzine, and
Aids Center. Elena created
the queer podcasts *Ways to
Adopt* ("Пути принятия")
and *Daily Life of a Lesbian*
("Будни лесбиянки").

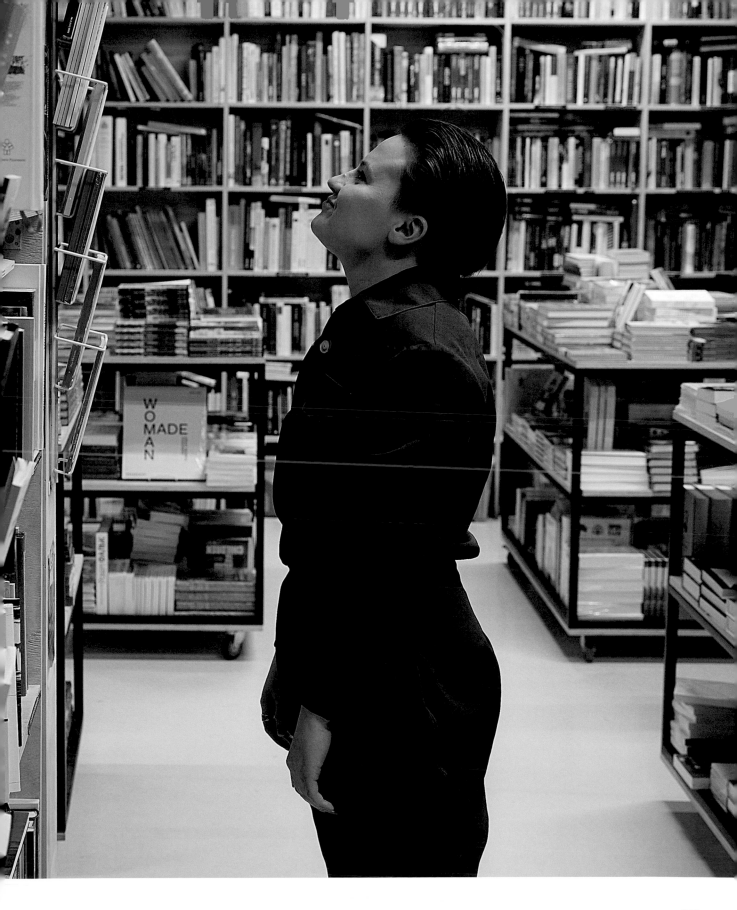

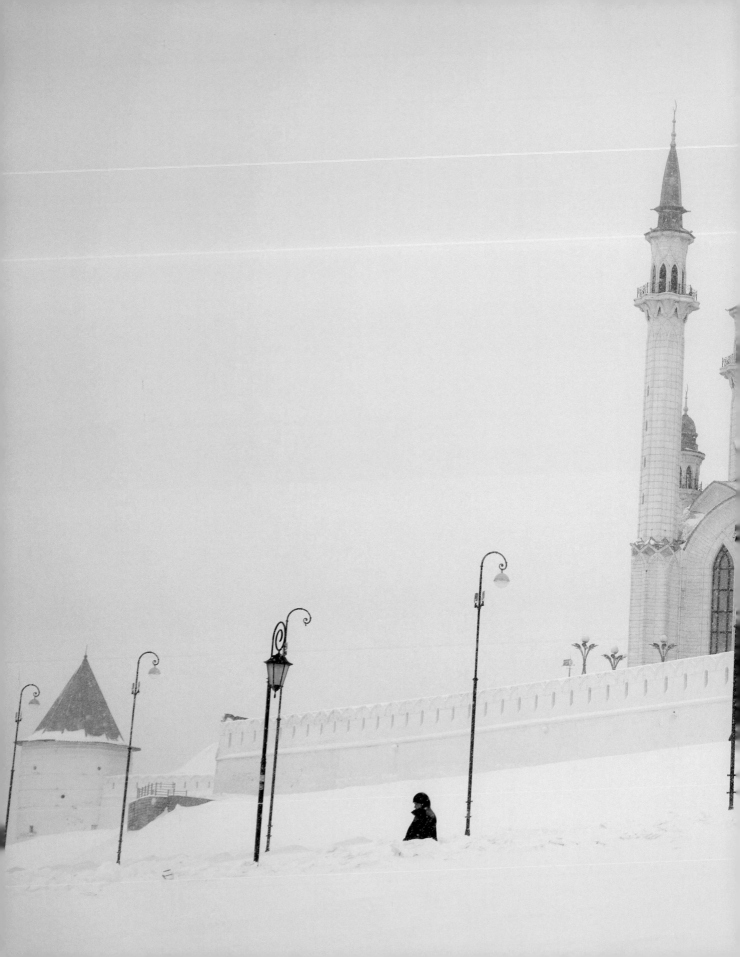

Kazan, February 2022. Kul Sharif Mosque, located in Kazan Kremlin, is one of the largest mosques in Russia.

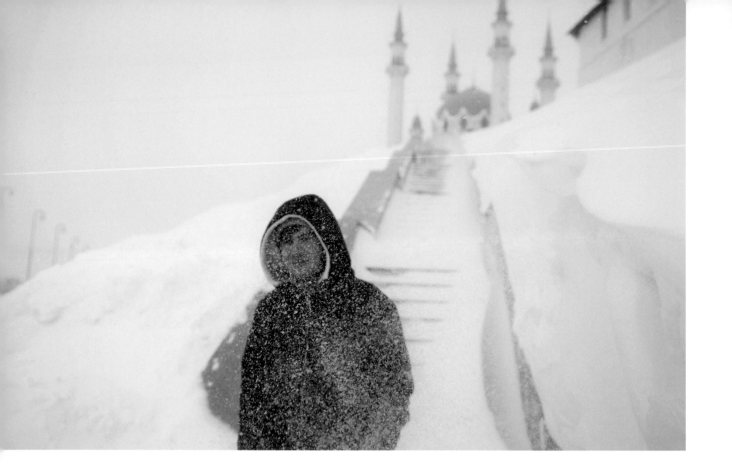

Ilfat
Ильфат

Kazan, February 2022.
Ilfat near the Kazan Kremlin. Originally from Uzbekistan, Ilfat has cerebral palsy. Recently, he took the brave step of coming out to his parents and has since started going to therapy. On his public Instagram account, Ilfat shares his thoughts, concerns, and experiences related to his sexuality. He believes that being open makes him feel stronger and has learned through therapy that ultimately he holds the power to embrace and accept himself.

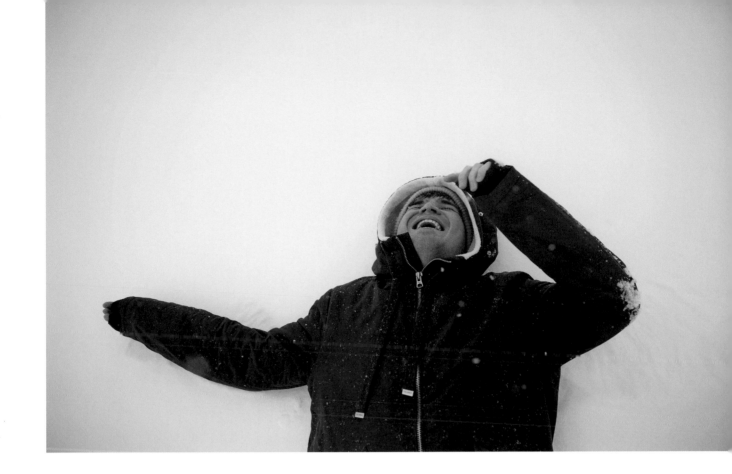

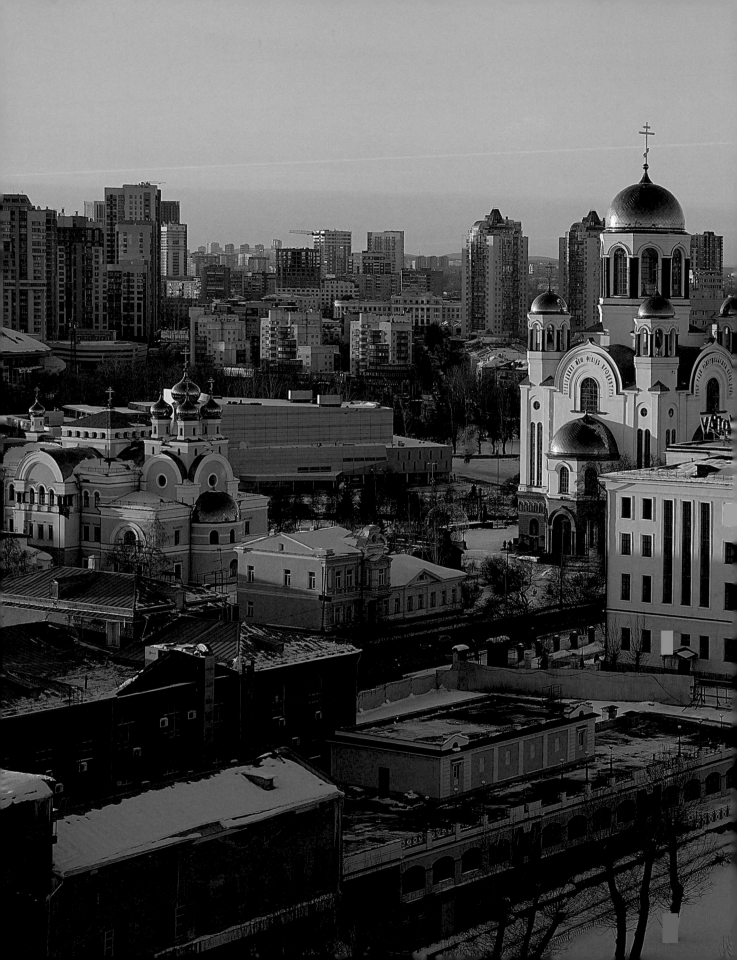

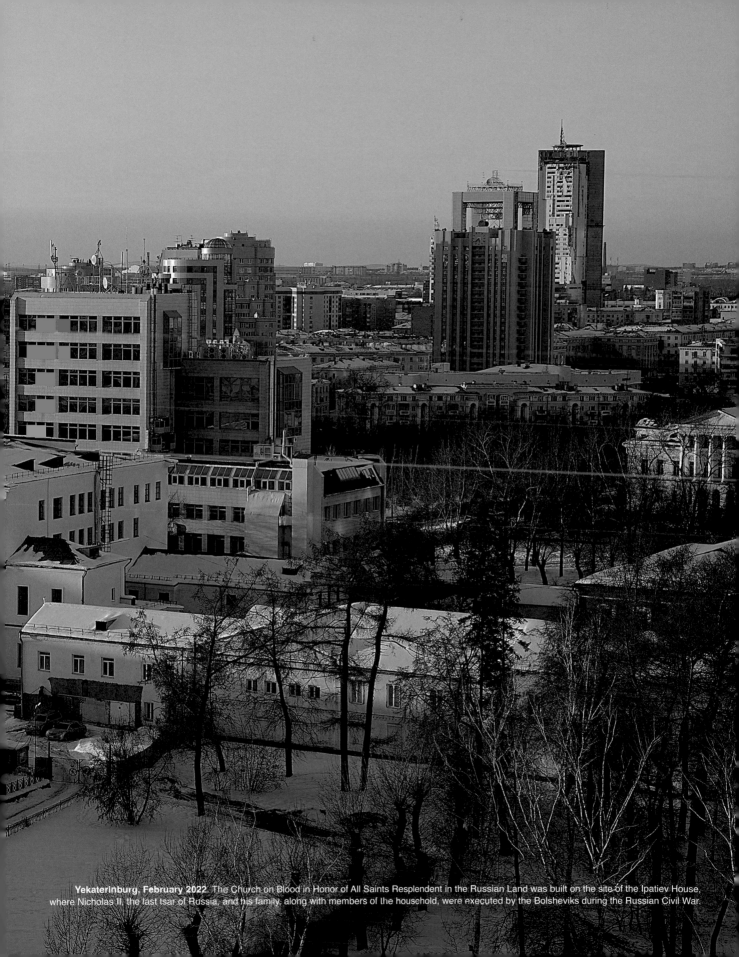

Yekaterinburg, February 2022. The Church on Blood in Honor of All Saints Resplendent in the Russian Land was built on the site of the Ipatiev House, where Nicholas II, the last tsar of Russia, and his family, along with members of the household, were executed by the Bolsheviks during the Russian Civil War.

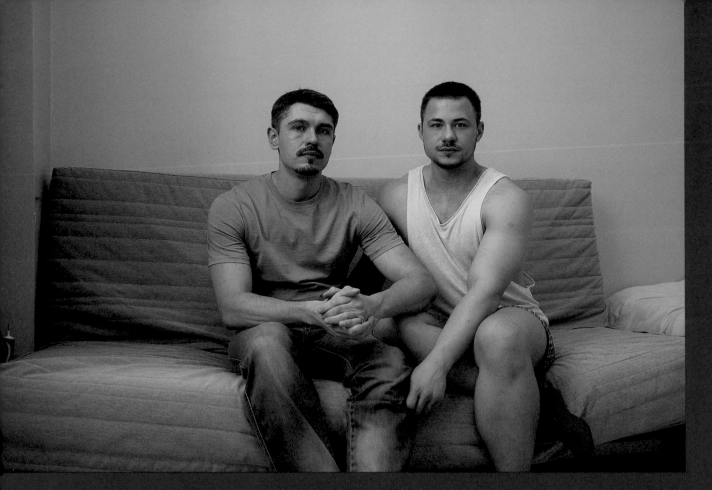

Ilia
Илья

Dima
Дима

Yekaterinburg, February 2022.
Ilia (left) and Dima have been
in a open relationship for nine
years. They organize queer
parties, specifically focused on
cruising, and sell sex toys.

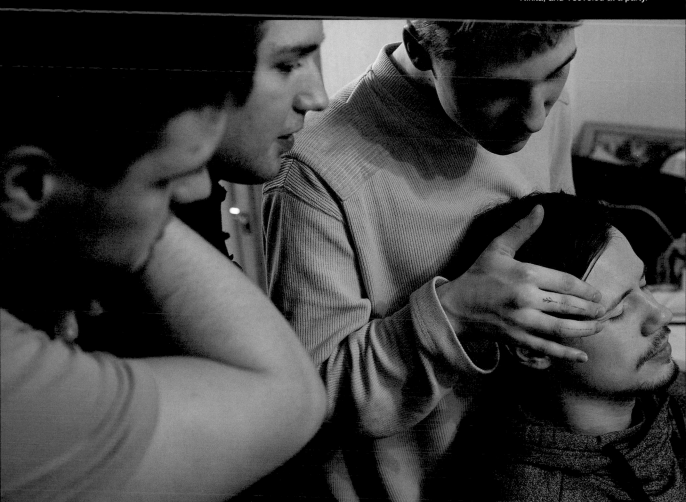

Yekaterinburg, February 2022.
From right to left: Vadim, Nikita,
Nikita, and Vsevolod at a party.

Konstantin
Константин

Yekaterinburg, February 2022.
Konstantin cleans an aquarium. At the age
of twelve, Konstantin recognized that he was
attracted to men. Wanting to gauge his mother's
response, he asked her how she would react if she
discovered her son was gay. To his dismay, she
said she would curse him. As a result, Konstantin
made the decision to conceal his sexuality. After
being married to a woman for eleven years, he de-
cided to come out and ended his marriage. Despite
the challenges he faced, he became involved in
the LGBTQ community. He started by volunteering
at an LGBTQ center and eventually established a
support group, through which he organizes various
activities including sports events, movie nights, and
community gatherings, creating opportunities for
local gay individuals to come together and connect.

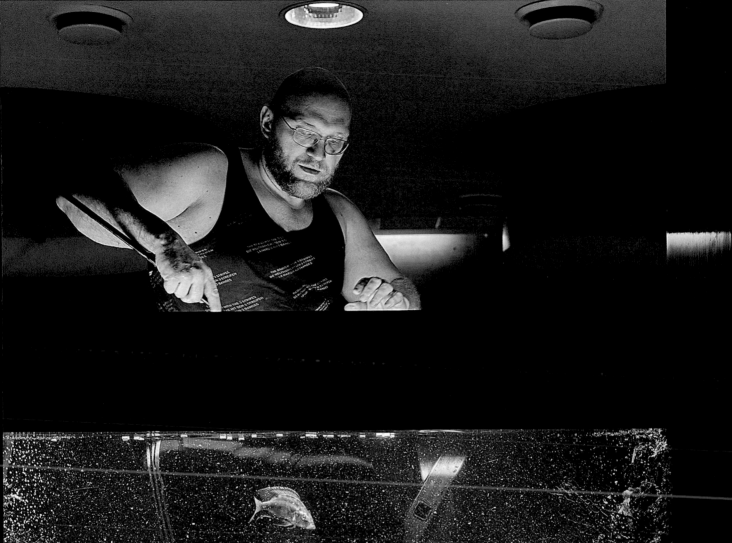
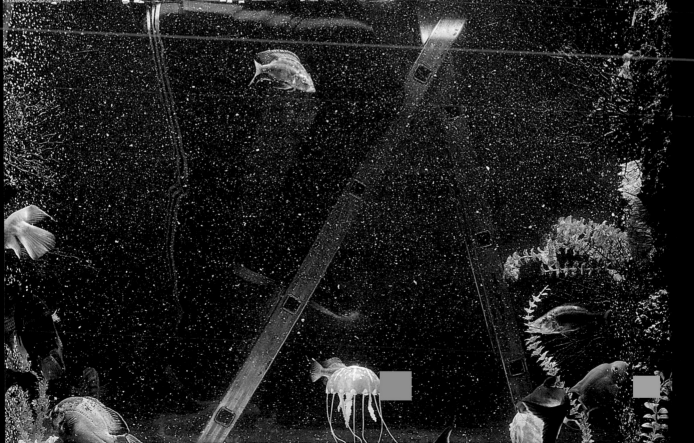

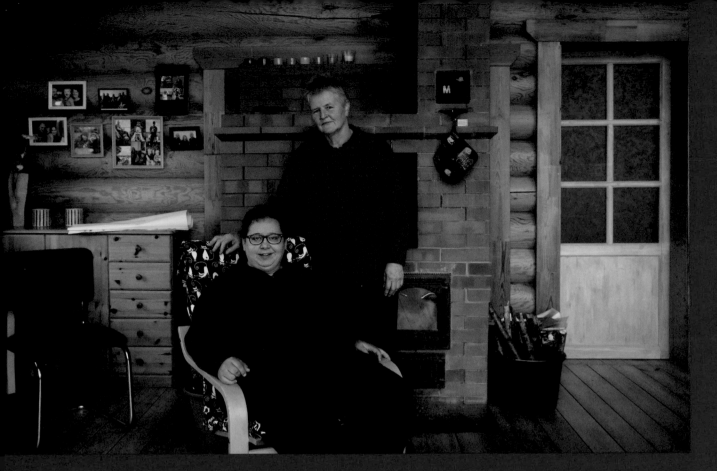

Gudrun
Гудрун

Anja
Аня

Krasnogor, November 2021.
Gudrun and Anja, a German
couple, have an eco-camping
site on the outskirts of the
small village of Krasnogor,
ninety miles from Moscow.
Anja, who studied Slavic
studies in Kaluga, Russia,
from 1991 to 1992, made the
decision to move to Russia
from Germany in 2004. She
met Gudrun in Russia in
1993. Gudrun relocated to
Russia in 2014.

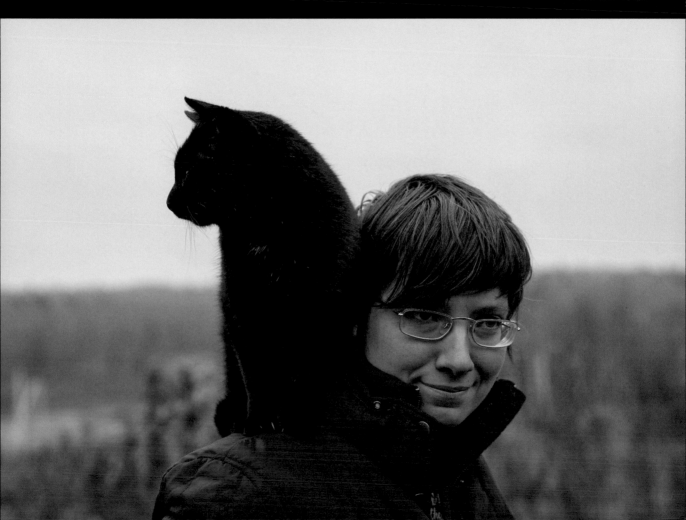

Alyona
Алёна

Nael
Наиль

Krasnogor, November 2021.
Alyona (left) and Nael are a
transgender couple.

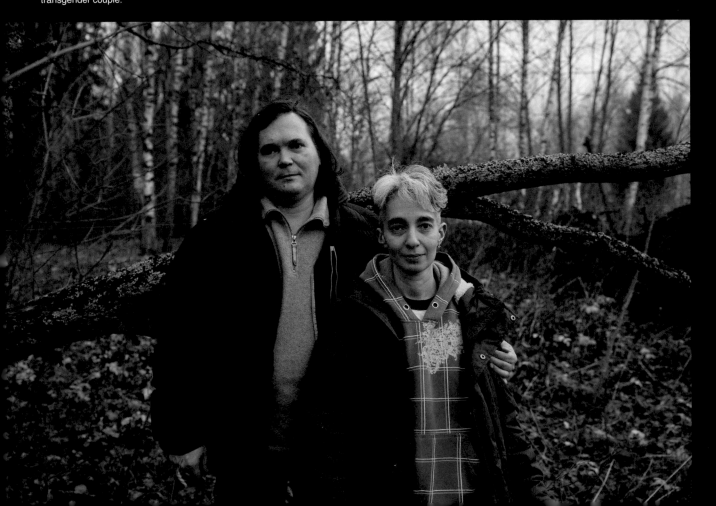

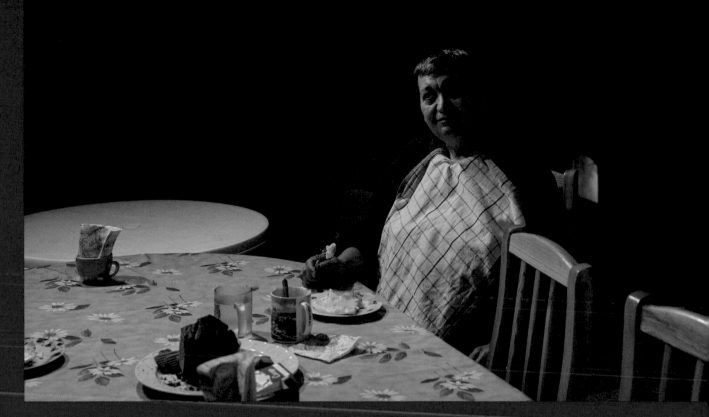

Elena
Елена

Krasnogor, November 2021.
Elena at her eco-camping site.

Svetlana
Светлана

Lake Baikal, February 2022.
Svetlana walks on the frozen
Lake Baikal. She works as
an art director at the night
club Bohemique, where
she organizes parties for
LGBTQ people.

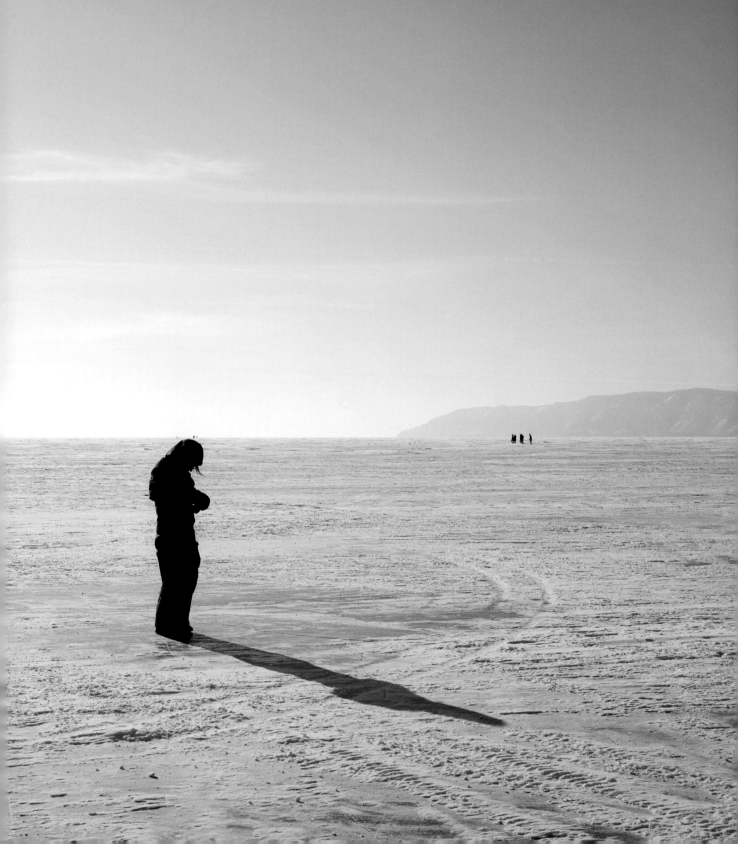

Valery
Валерий

Irkutsk, February 2022.
Valery works at the Yeltsin Center.
During a visit to a gynecologist,
when Valery mentioned that she
is asexual, the doctor responded,
"Why did you come then?" and
refused to conduct an examination.

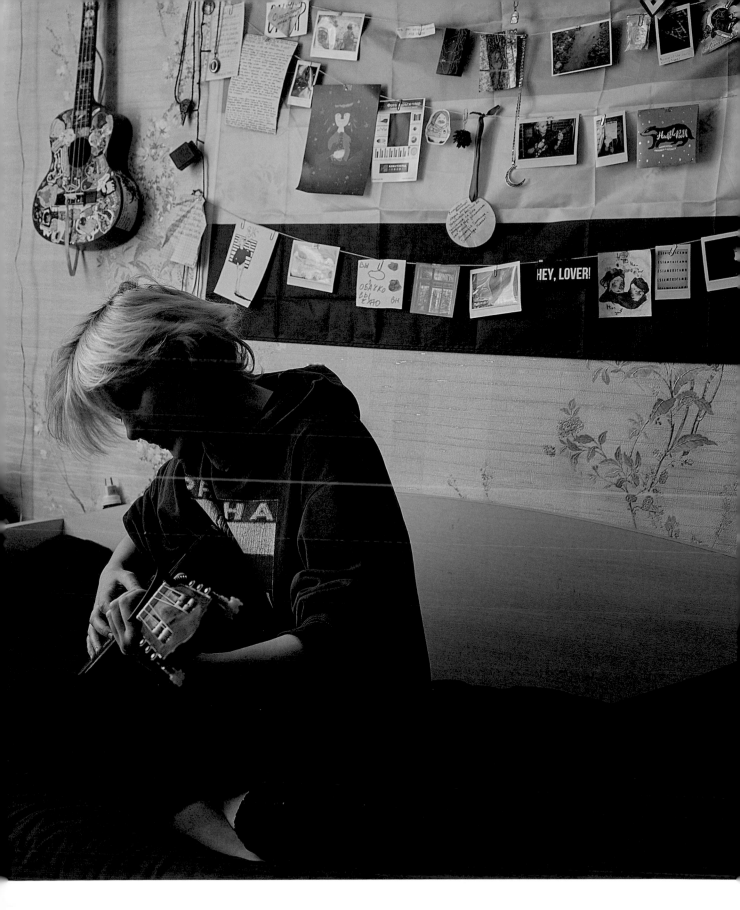

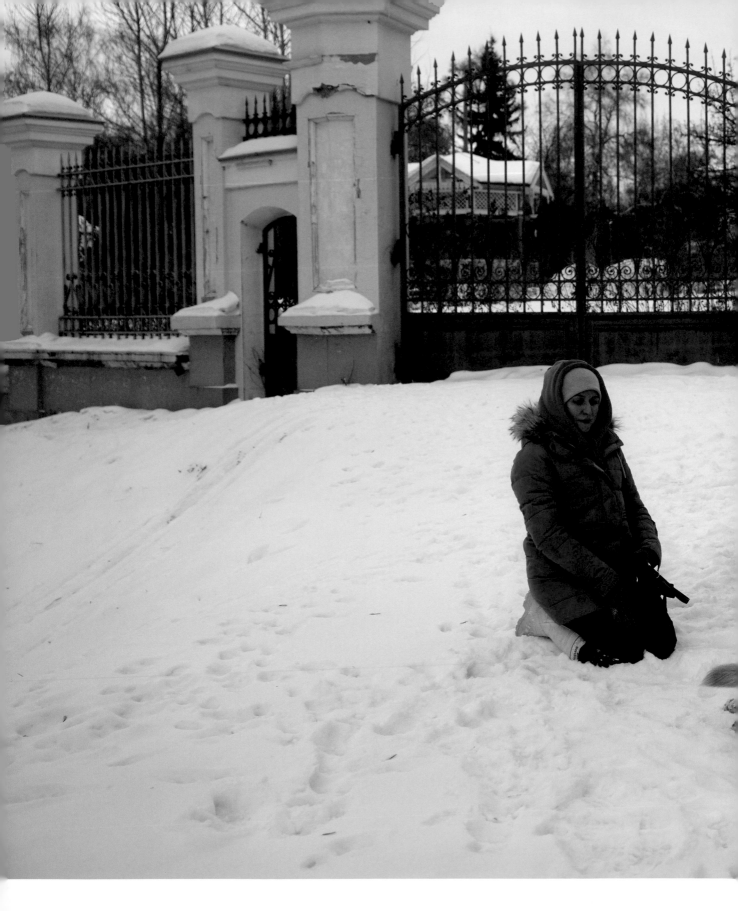

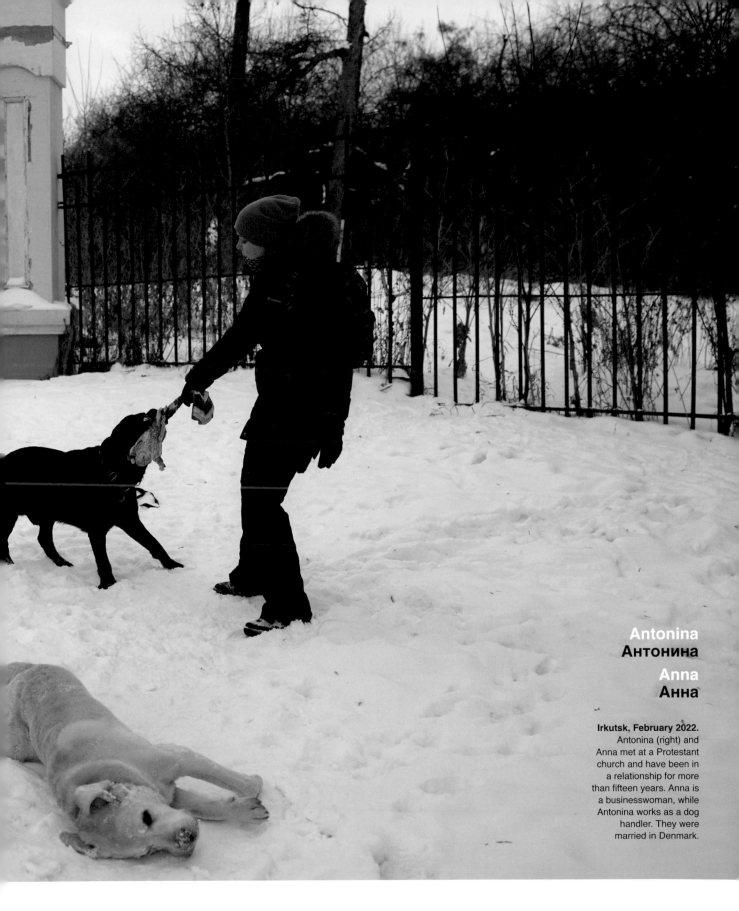

Antonina
Антонина

Anna
Анна

Irkutsk, February 2022.
Antonina (right) and
Anna met at a Protestant
church and have been in
a relationship for more
than fifteen years. Anna is
a businesswoman, while
Antonina works as a dog
handler. They were
married in Denmark.

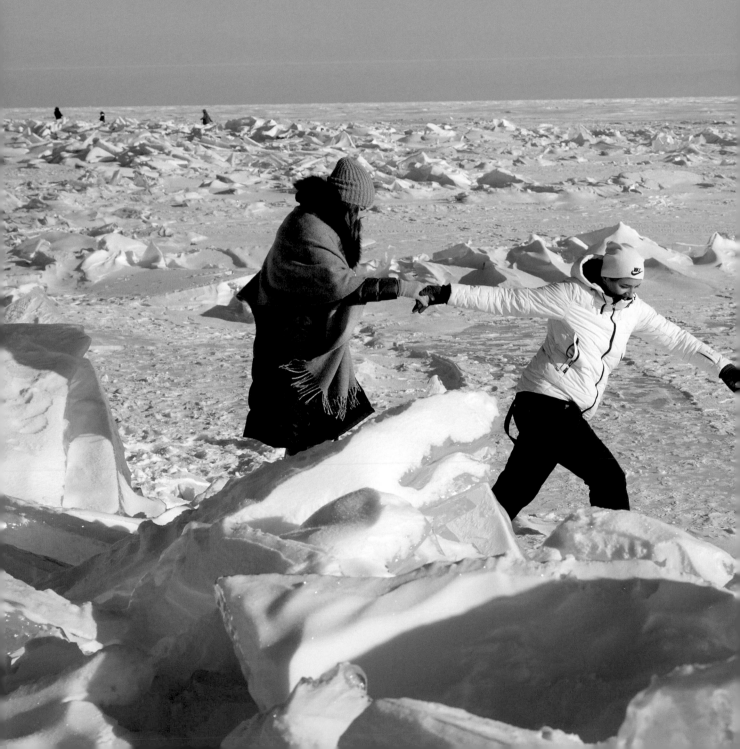

Valeriya
Валерия

Sofiya
Софья

Lake Baikal, February 2022.
Valeriya and Sofiya have been
together for eight years. They
work as political consultants.

Acknowledgments

The photographs presented in this book were made possible by Jon Stryker: philanthropist, architect, and photography devotee.

This book was made possible in part by a grant from the **arcus** * **FOUNDATION**

I want to thank my parents, my sister, and my big family for their love and for always believing in me. You are my strength, my support, and you are always in my heart.

My love to my partner Alexey Shlyk. You are the most talented, smart, and caring person I know. Thanks for everything. Let's keep going on our wonderful journey.

This book would not be possible without Jurek Wajdowicz, Lisa LaRochelle, Yoko Yoshida-Carrera, and everyone at Emerson, Wajdowicz Studios (EWS). Thank you for this opportunity, for your support and belief in me. I truly enjoyed working with you, and I'm so happy about the result! A big thank you to Maciek Nabrdalik, who introduced me to Jurek Wajdowicz.

Thank you to Sasha Kazantseva for a thoughtful and caring introduction text for *Ordinary People*. Thank you, Jon Stryker and the Arcus Foundation, for your remarkable support. I am immensely grateful to Ben Woodward and everyone at The New Press for making this book a reality. I couldn't imagine a better place.

My thanks to those who introduced me to the heroes of the project and the time you have devoted to me, either in front of the lens or connecting me with the community.

I want to thank W. Eugene Smith Memorial Fund, Friedrich-Ebert-Stiftung, and personally Scott Thode, Beate Eckstein, and Pia Bungarten for supporting this project at an early stage.

My deepest gratitude goes out to Bertan Selim, who believed in my project from its beginning, asked important questions, and supported it throughout.

I want to thank Prof. Dr. Pamela Scorzin, Kai Jünemann, and Christoph Bangert for their invaluable support and guidance.

A big thank you to Sudhanshu Malhotra, for our Skype calls and very interesting conversations. The title *Ordinary People* was born thanks to you.

My deepest gratitude to Luca Rocco for your support throughout the years.

The project has a website version and an artist publication thanks to my dearest friends Marius Popa and Charlotte Decoster.

Special thanks to Sergei Puchkin, Alla Chikinda, and Karen Shainyan.

I am blessed to have a Belarusian and German family as well. My love and gratitude to Valentina, Sabine, Sigrid, Bodo, Vladimir, and Jochen.

Big love and thank you to my friends: Anna, Alexandra, Anastasia, Alexis, Brandon, Danielle, Daro, Emile, Emine, Esther, Fran, Iskandar, Jenny, Jessica, Julia, Justin, Katya, Lea, Leila, Lisa, Luisa, Martin, Mitya, Max, Nika, Pauline, Ruben, Sander, Sasha, Shane, Sofie, Tanya, Tiago, Tim, Tomasz, Vlad, Xonya, Yaro, Yvonne, and Zhenya.

With love, Ksenia

*The Arcus Foundation is a global foundation dedicated to the idea that people can live in harmony with one another and the natural world. The Foundation works to advance respect for diversity among peoples and in nature (www.ArcusFoundation.org).